MONUMENT

EDITED BY DAVID WHITNEY

MONUMENT

EDITED BY DAVID WHITNEY

LYNN DAVIS

LYNN DAVIS
MONUMENT

Preface by Patti Smith

Introduction by Rudolph Wurlitzer

Arena Editions

For Ayrev

MONUMENT

Travel is its own book, its own reward. Our experiences are internalized, woven within memory. The spoils of our journey may include a cherished image amid a spread of Kodaks—our amateur travelogue. But absent is the spiritual wash, a searing light, a breathtaking harshness, a certain sense of things that we are powerless to capture or to express.

The artist, in turn, sacrifices his leisure, the pleasure of being vague, of drifting half-present or merging unconsciously with the terrain. For the artist is driven, is one apart, estranged from all save his own eye. All confidence, vision, marshaled to secure the shot not shot by us. He must comprehend the equation that produces the architecture and landscape we call sacred. He must be aware, dogged, unable to relax. That is how this artist travels. And only after the images emerge, are washed and hung to dry, can she say, "This is good."

And why is it good? For its own sake. For magnifying the artist's process. For exalting the principles of nature, the acquired wisdom of man and that to which he aspires—illumination.

Where black is bright as dead. Where all things are another. Where the sea is the desert. Where decay is transformation. Where ice is bone is torso. Stone is the mottled skin of a guardian. The spine of a delicate temple. The organs of a ruin. The shadows of Yemen—the musical ribs of the earth. The vast insufferable curve of a wall.

Where external space leads into inner space. Where the spray of a fall is as dense as the mane of a horse. Where a man disintegrates into rainbow. The artist brings the oneness of these poles into focus. Where one looks through the solid. Where emptiness is charged, clothed in form.

A breath of humanity startles one into the twentieth century. A power line. A young tree. A bit of scaffolding. Restoration. Debris. A beat truck. A telegraph pole—a small, very distant electric crucifix. Eclipsed by the plane of the earth. The clouds of Cambodia. The mounds of Syria. A shaft. A structure. A column. An arch. Perpetuating memory. Fashioned by whim, wind or slave.

The artist attempts to be removed, and yet she is laid bare. Her work embodies heart-ache, prayer, the physics of the sun, the womb. Solitude. Unflinchingly and beautifully cruel. Unveiling the monument's soul, so heightened in isolation, so exposed as art.

As one passes through the leaves of this book, where are they traveling?
Within themselves. And what will they find? The waterfall.
The pyramid. The sloping dune. That which is within us all.
A present yet eternal energy. A sameness. An aloneness.
A dignity so crushingly remote that only a god may rival.

—*Patti Smith*

INTRODUCTION

Images of silence. Images of erosion and decay. Images caught stealing time. Monumental forms poised in "mid-passage," suspended into a "freeze" before their long slide to extinction. Journeys that pass beyond the lists of time or, in the case of rock or ice, the geological seizures that spewed them forth.

No conceptual or cultural agendas support these contemplations. There are no people. No footprints, actual or implied. No literary descriptions or interpretations. As celebrations of emptiness and impermanence, the beauty of these disintegrations cannot resonate without pointing beyond themselves, towards a final collapse of form into the essence of matter: air, earth, fire and water. Mysteries that cannot be measured or followed, reduced to echoes from the sublime rot of history. Until, of course, the whole dance is resurrected and begins once again.

A geyser, created by fire, exhaled by earth, its vertical flight probing into air, a vaporous trail disappearing into ether before the mind can assimilate the power of its presence.

An iceberg, poised between sea and sky, is a reverie on death, of matter dissolving into emptiness and then back again into form. Floating like a phantom, it becomes a prism of frozen water, crystalline and blue in the sun, ominous and unearthly in mist; a parade of transparencies proceeding like an hallucination across unknown depths boiling with hidden fear.

The insistence of a rock protruding from the parched Australian desert; a massive cliff curving like a giant wave; the opening of a sacred gorge, feminine and secret in its initiations.

On first sight, a collapsed pyramid is simply a pyramid. Massive in its erosion, mysterious in the power of its construction. On closer observation, the arranged triangle disappears. The emptiness of sky and earth becomes solid, the pyramid empty, a reversal of positive and negative space.

A "Walking Buddha" strides forward as within an illuminated dream, in the fluid and flowing attitude of "becoming." The slightly curving fingers of the right hand reflect the courage of "walking on," beyond gender, neither coming nor going, but endlessly becoming. A flight through the air of one who no longer needs to move at all in order to be anywhere.

Two ancient Zimbabwe walls squeeze the light from the sun, their slow snake-like turn an invitation to rituals long forgotten. What is left is a claustrophobic passage that ends without resolution. A journey for its own sake, going nowhere.

An abandoned minaret at the end of the Arabian peninsula, once part of a great mosque, now desolate and forgotten, its base eroded by sand.

A bulbous cylinder-shaped Burmese pagoda seems to have arisen spontaneously from the earth—not designed, not formed, not preconceived. Its presence, more profound than mere beauty, transmits everything that is potential, that will arise and unfold. It is the womb and lingam joined, nothing less than the pulsating shape of creation, a statement with no beginning and no end.

To witness these remote symmetries is to enter into a meditation on the illusion of discovery, on the futility and ecstasy of the voyage itself. Contrasts and comparisons, indeed all metaphors, vanish before the shocking truth of their impermanence. The experience is, finally, a liberation, an absorption rather than a reflection, a terrible and joyful intimacy of transformation that commits itself to a circulation greater than the conceptual mind can manage, a fleeting awareness that all life, all creation, is a dream within a dream. Which leaves these images just as they are, in their own spaciousness.

—Rudolph Wurlitzer

PLATES

ICEBERG #3, DISKO BAY, GREENLAND, 1988

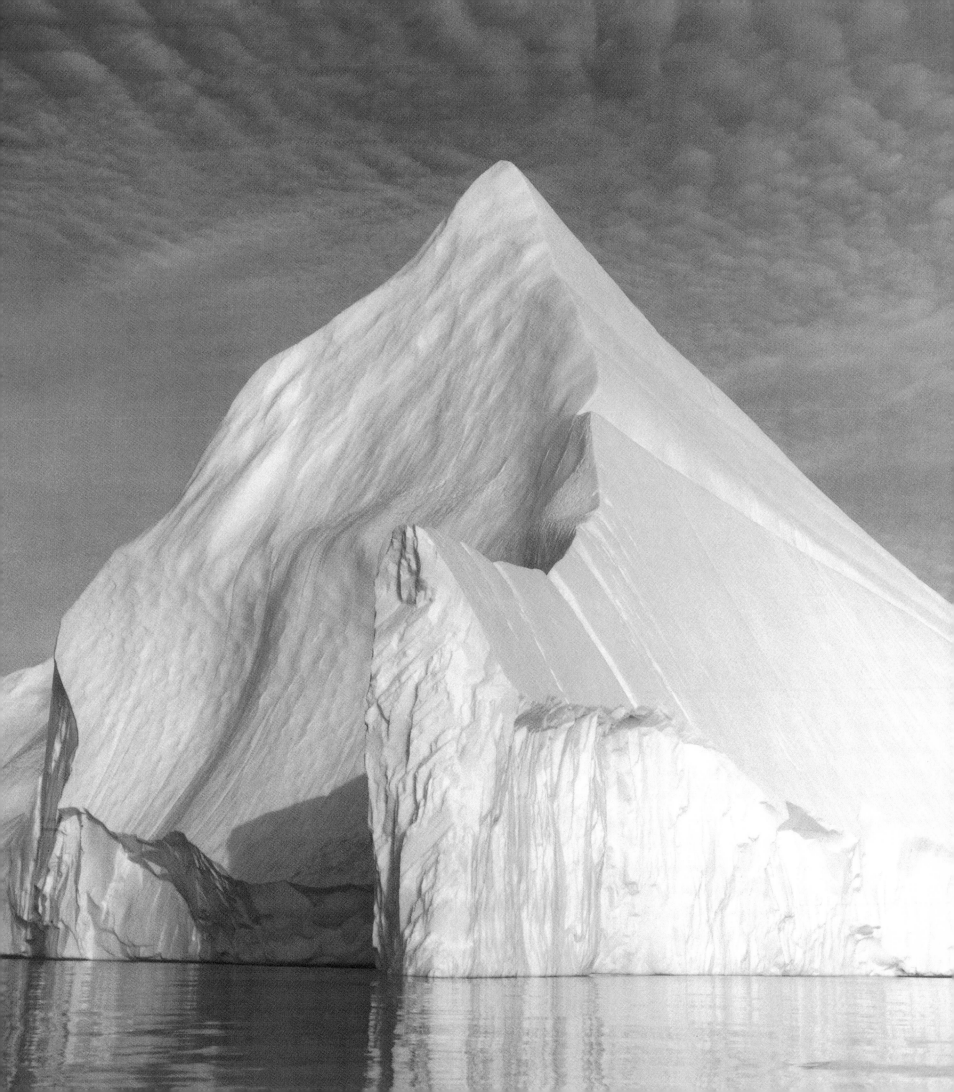

ICEBERG #6, DISKO BAY, GREENLAND, 1988

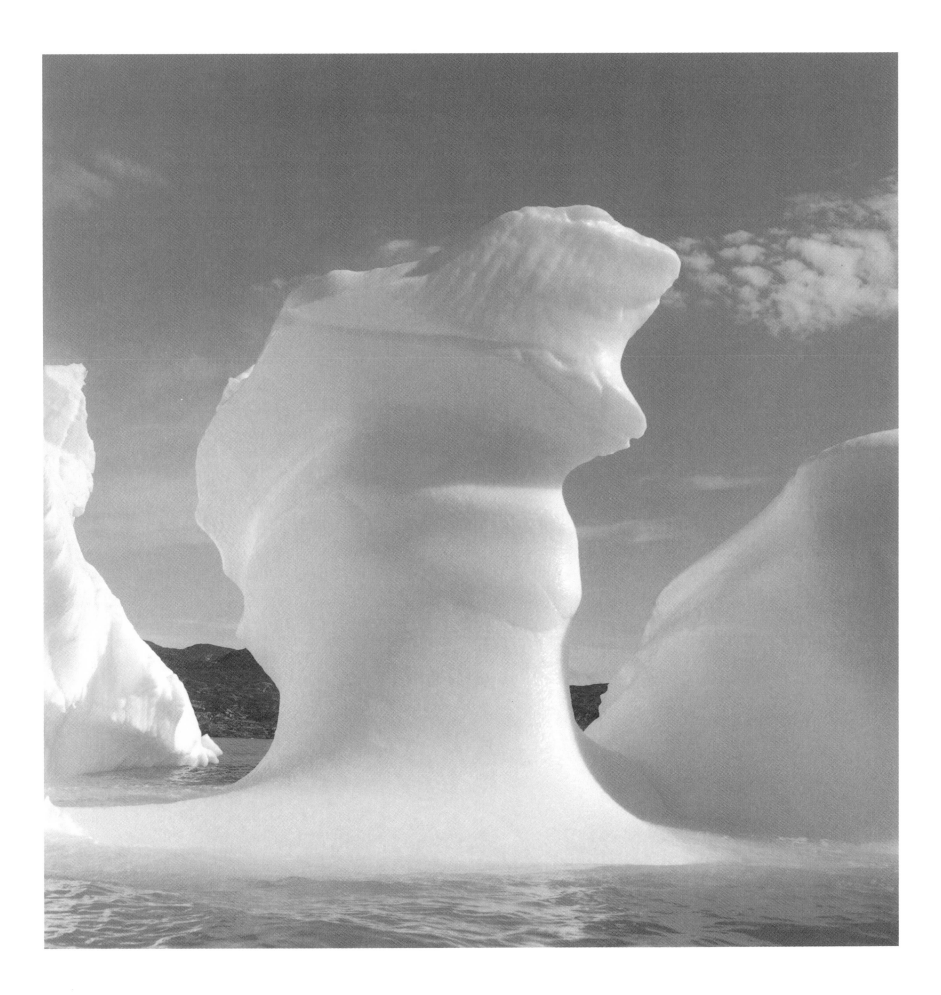

ICEBERG #13, DISKO BAY, GREENLAND, 1988

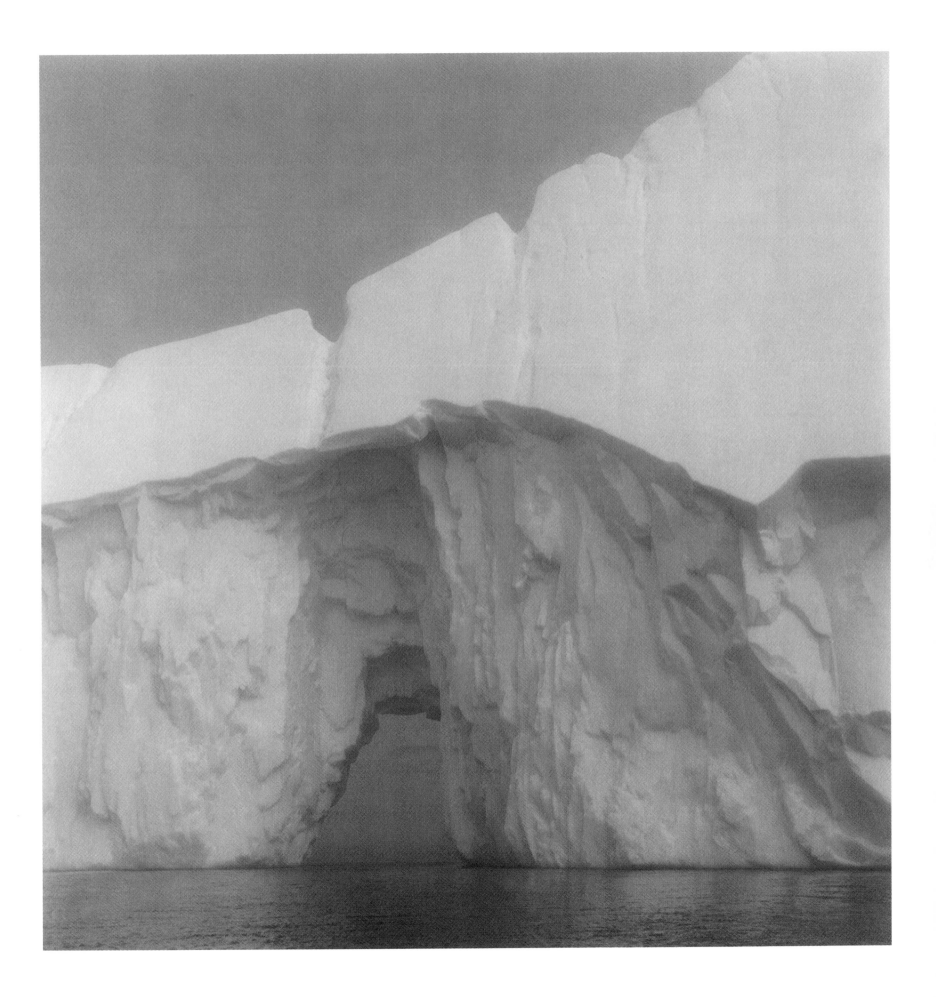

ICEBERG #5, DISKO BAY, GREENLAND, 1988

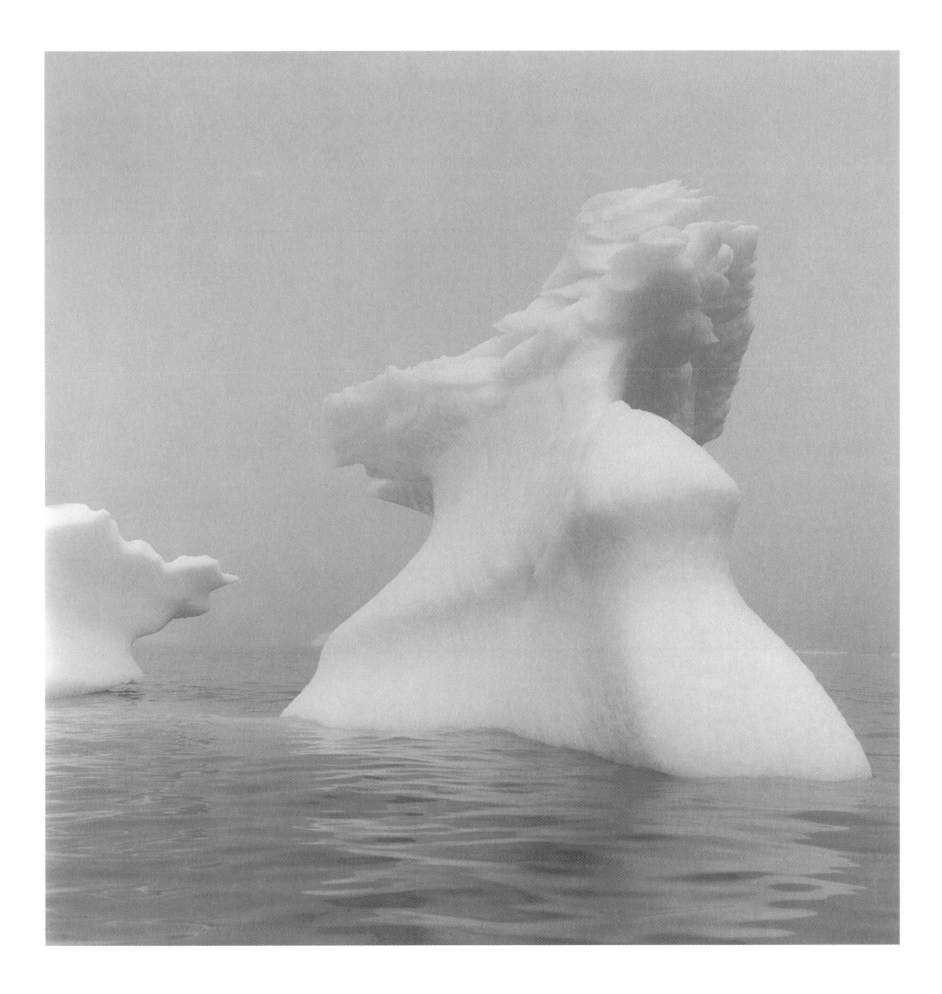

ICEBERG #15, DISKO BAY, GREENLAND, 1986

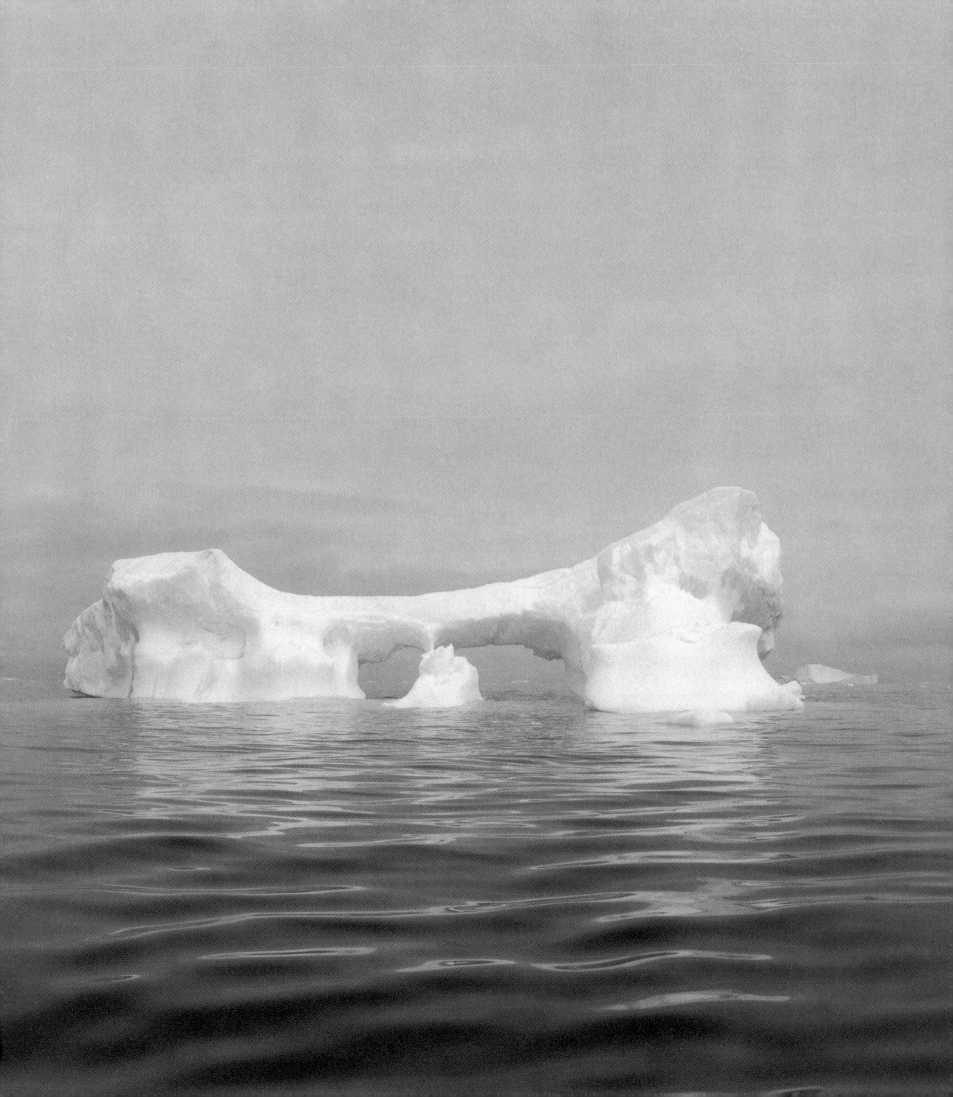

GIZA III, EGYPT, 1989

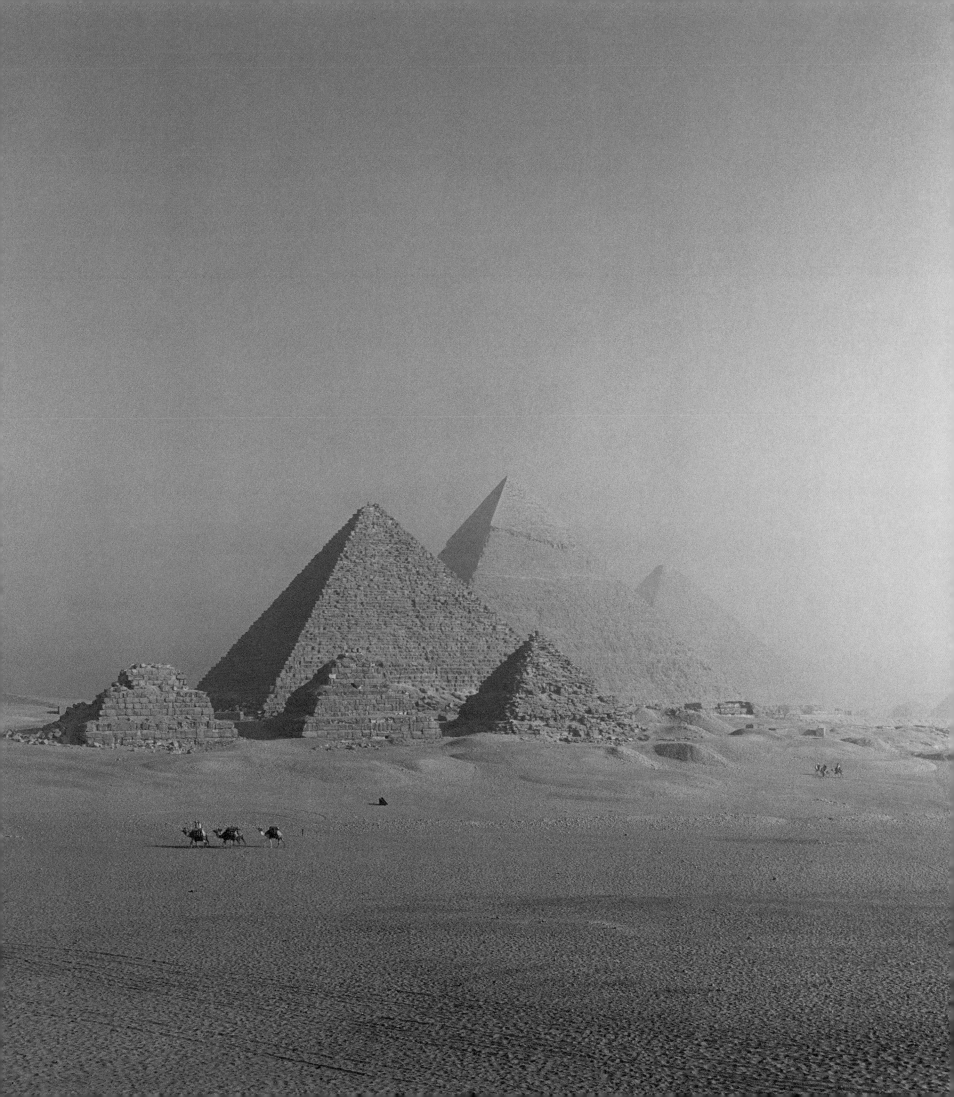

COLOSSI OF MEMNON IV, EGYPT, 1989

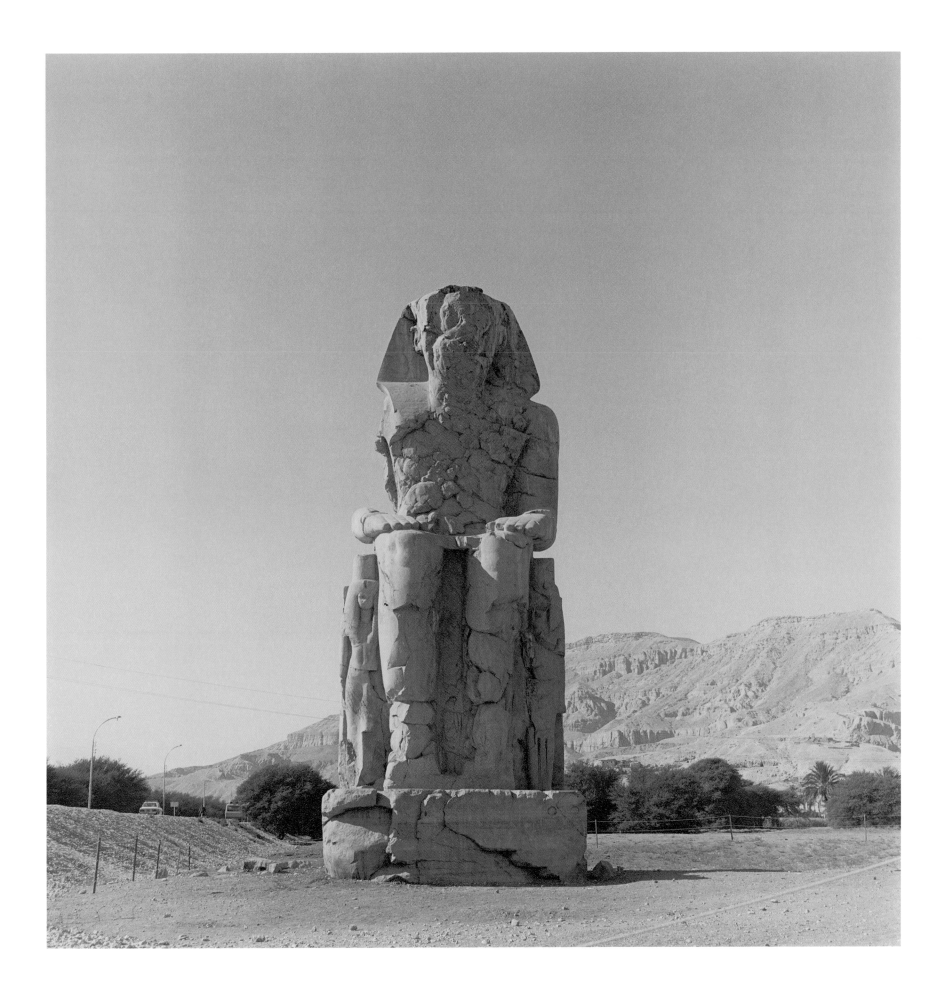

MEIDUM I, EGYPT, 1989

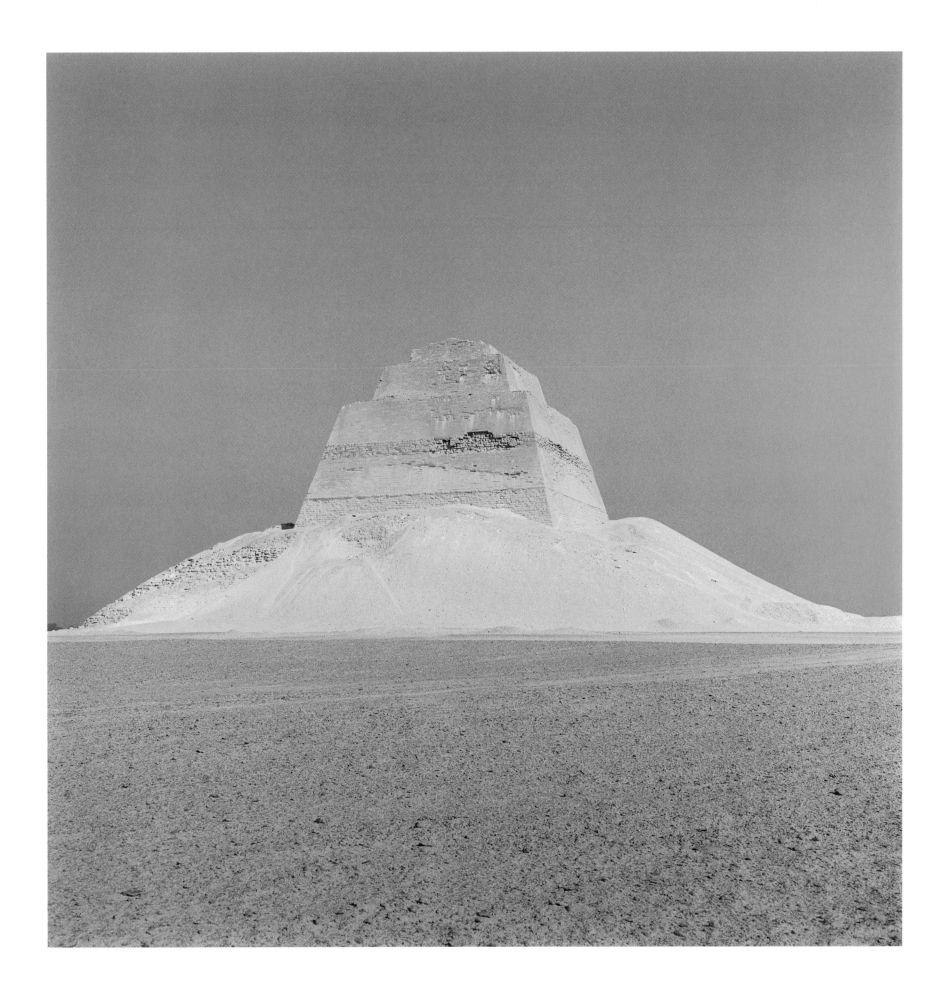

MEROE, SUDAN, 1998

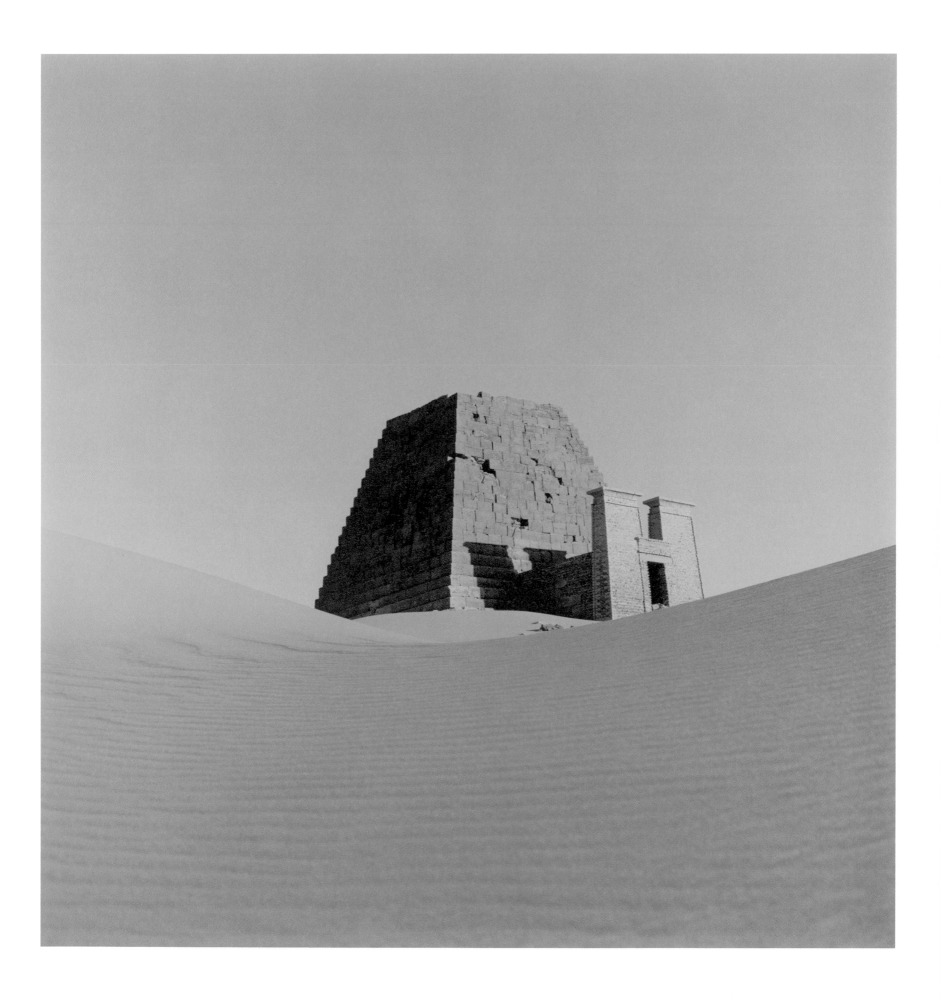

NAGA, SUDAN, 1998

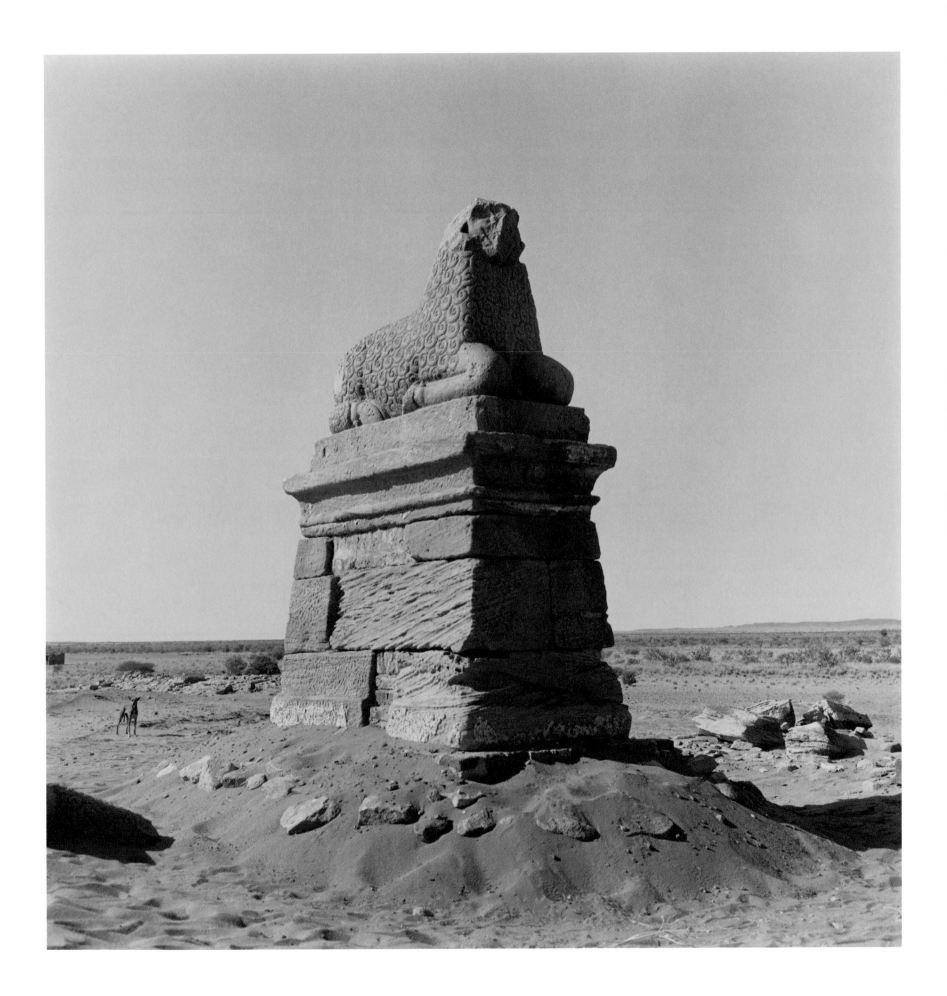

WALL AT SAQQARA, EGYPT, 1989

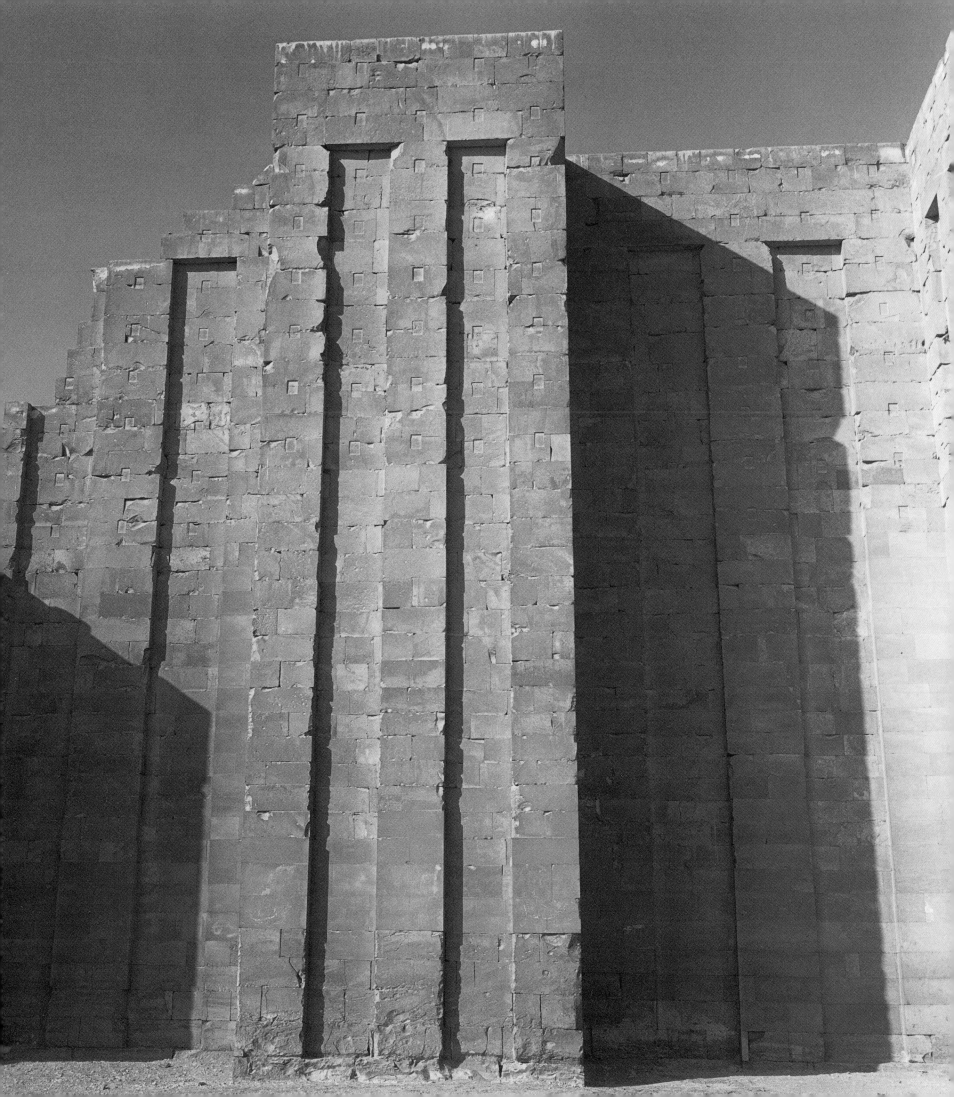

HIEROGLYPH, EGYPT, 1989

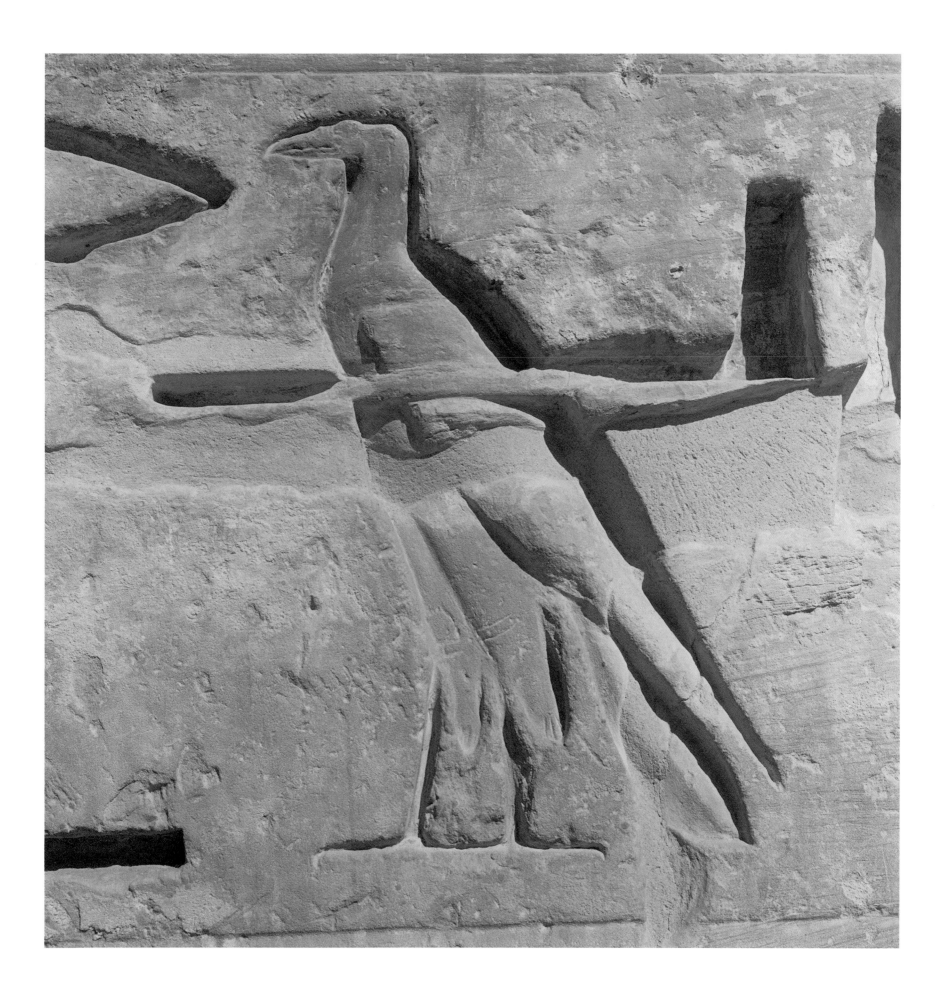

SAQQARA II, EGYPT, 1989

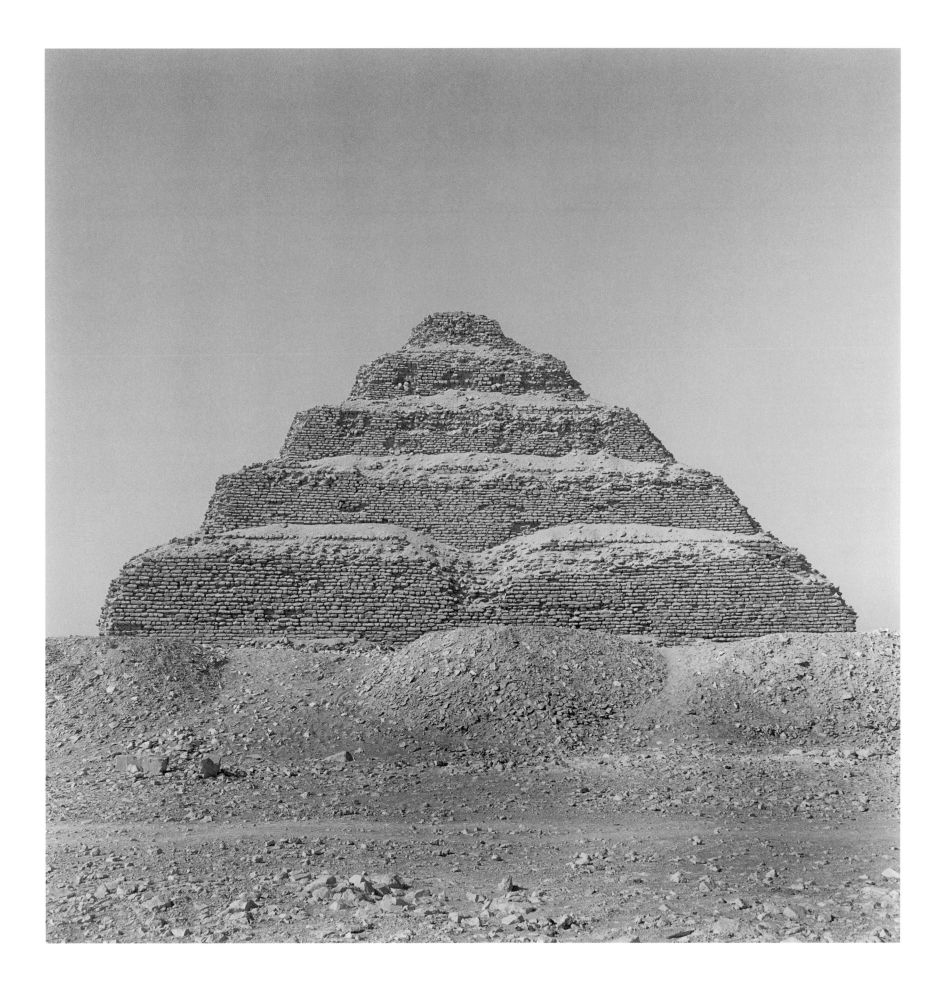

NEW DELHI, INDIA, 1990

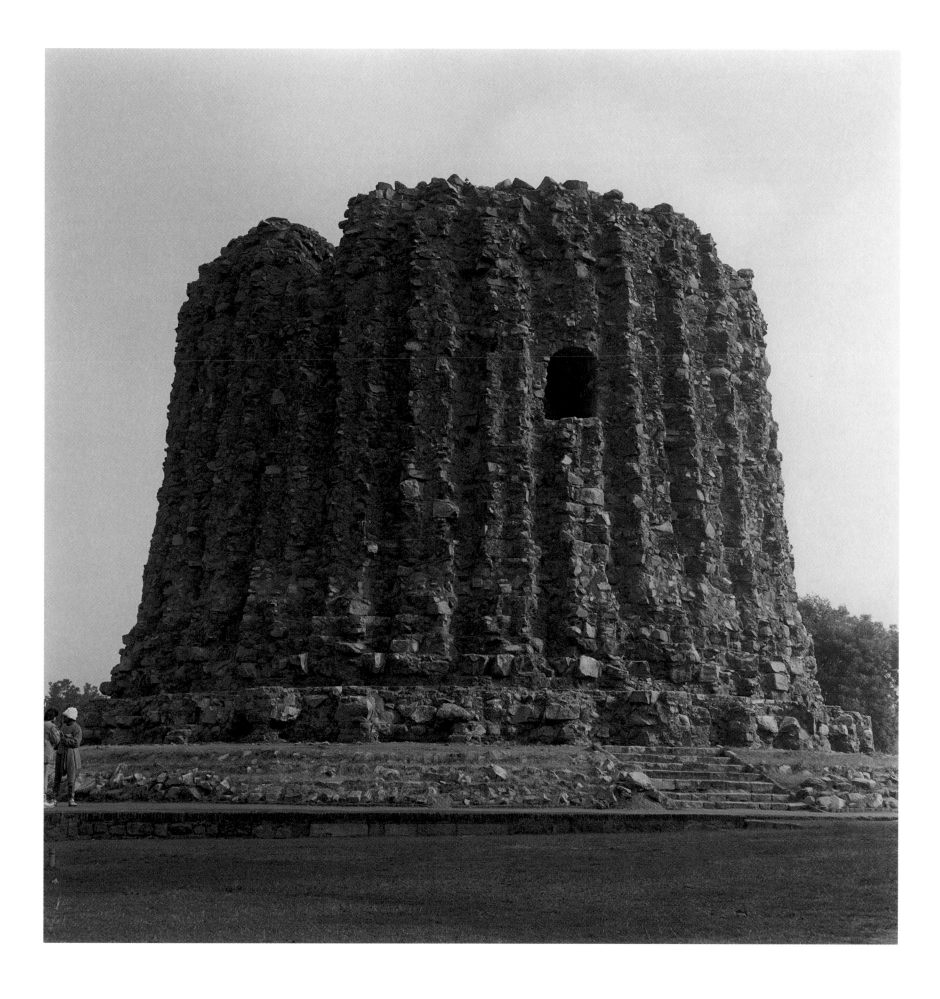

THE MEENAKSHI TEMPLE, MADURAI, INDIA, 1990

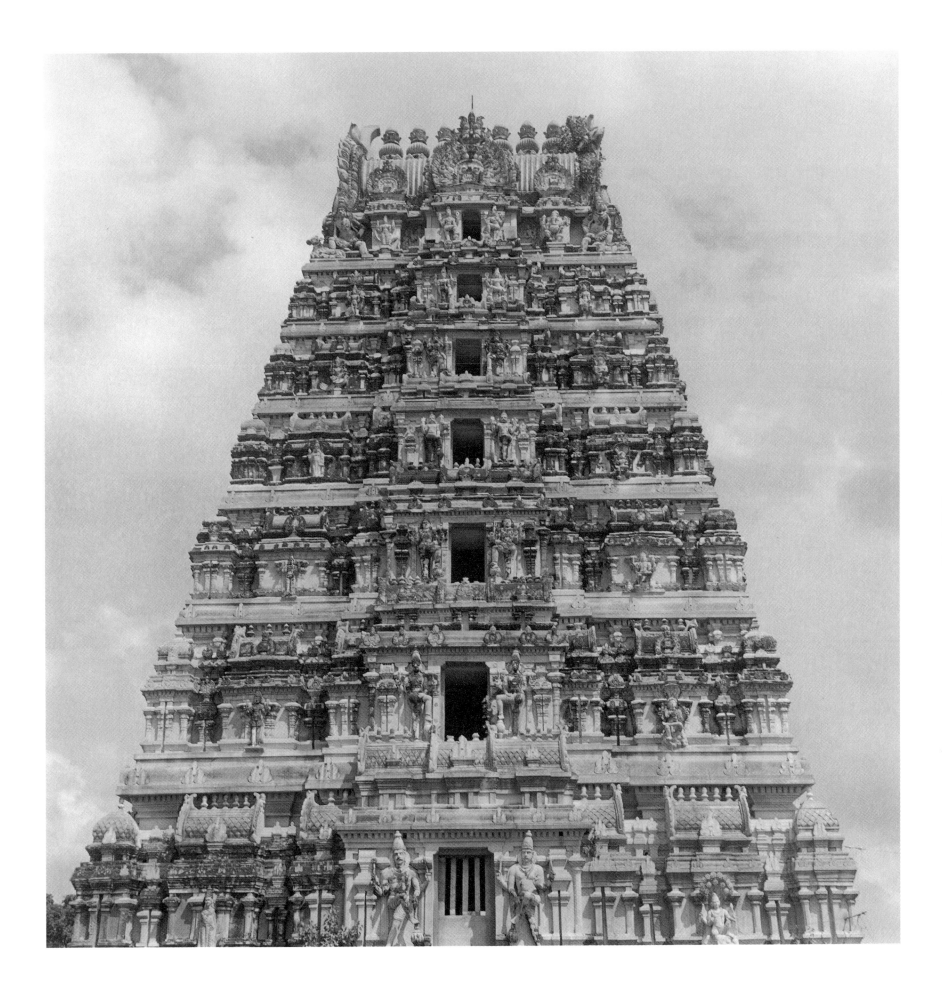

OLD FAITHFUL, YELLOWSTONE NATIONAL PARK, WYOMING, 1990

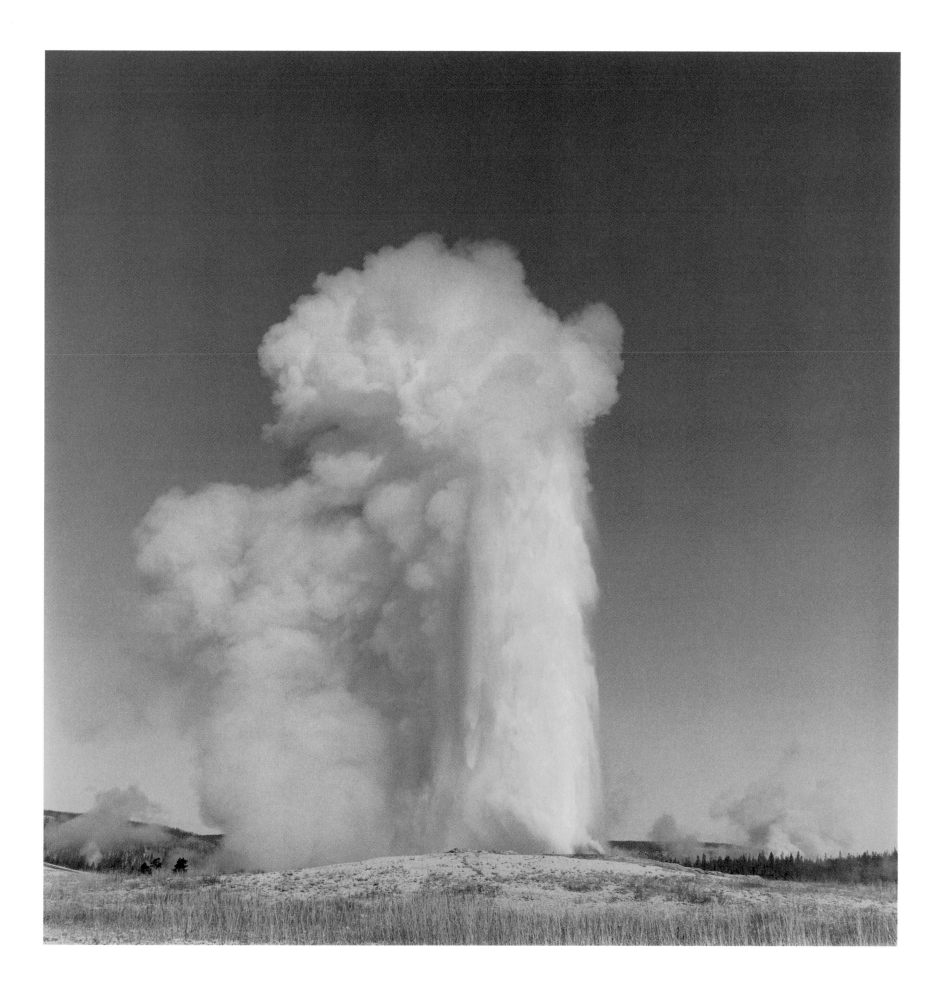

GRAND GEYSER, YELLOWSTONE NATIONAL PARK, WYOMING, 1990

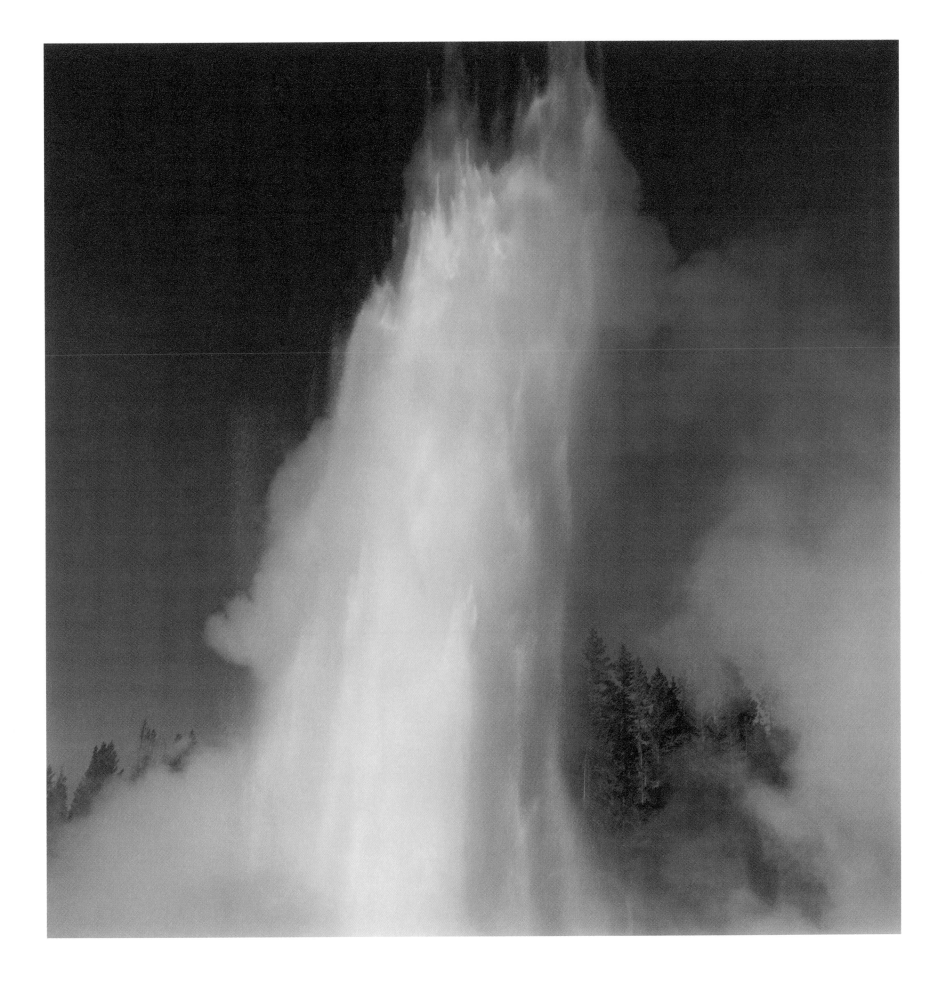

WAVE ROCK, HYDEN, WESTERN AUSTRALIA, 1991

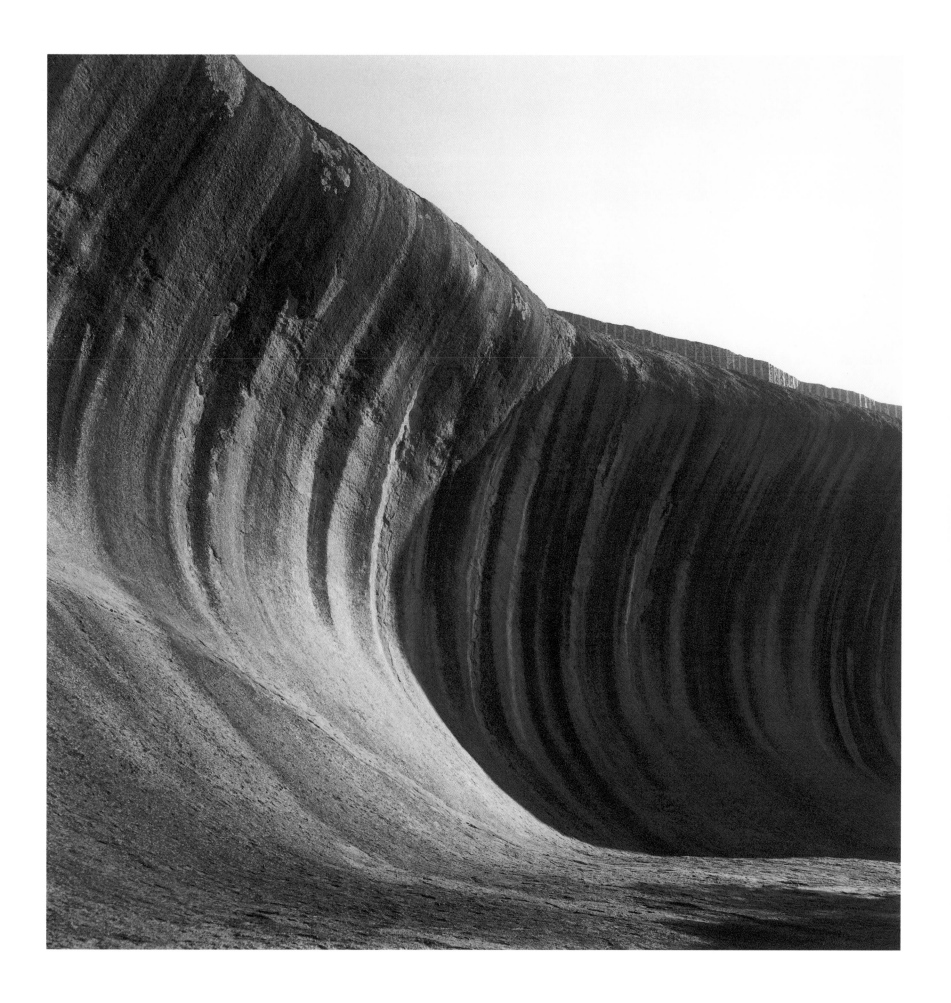

PINNACLES I, NAMBUNG DESERT, SOUTH WESTERN AUSTRALIA, 1991

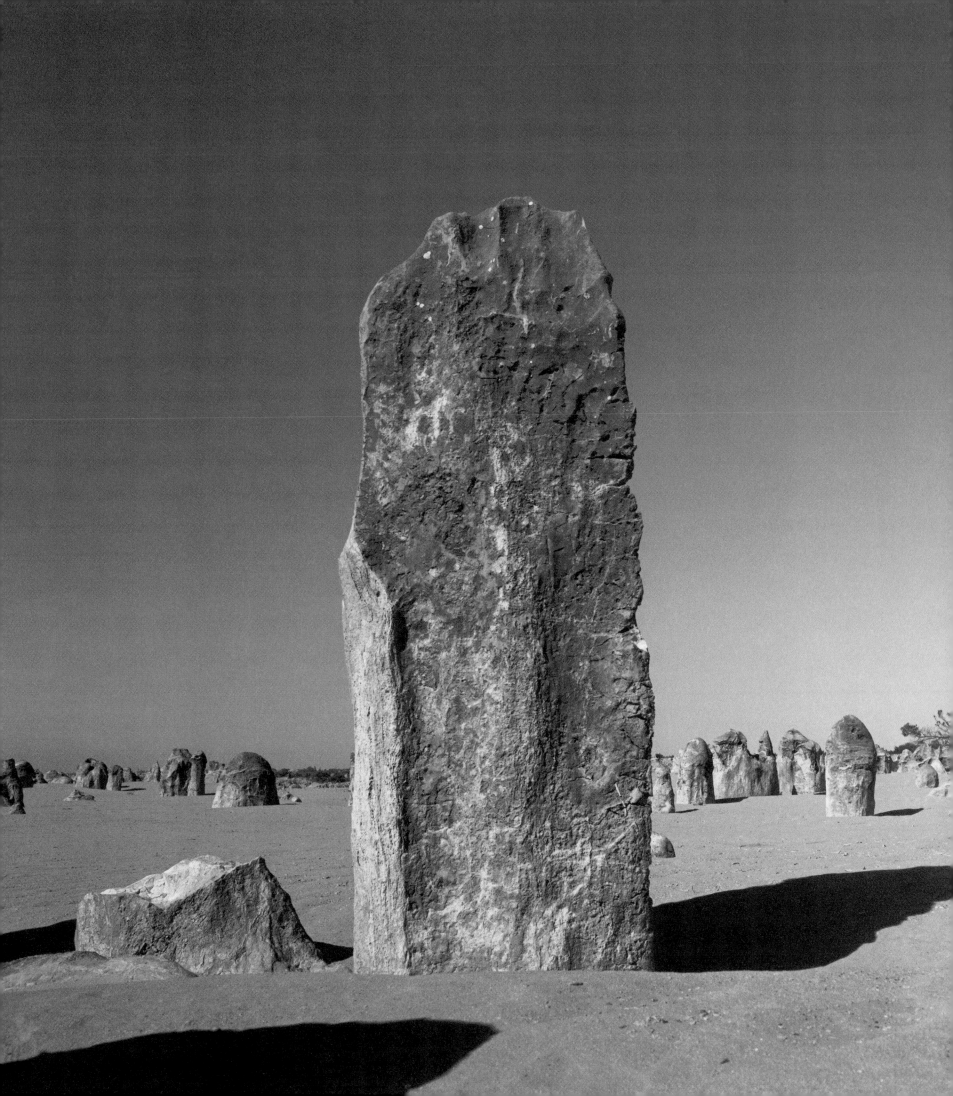

MT. OLGA GORGE, ULURU NATIONAL PARK, AUSTRALIA, 1991

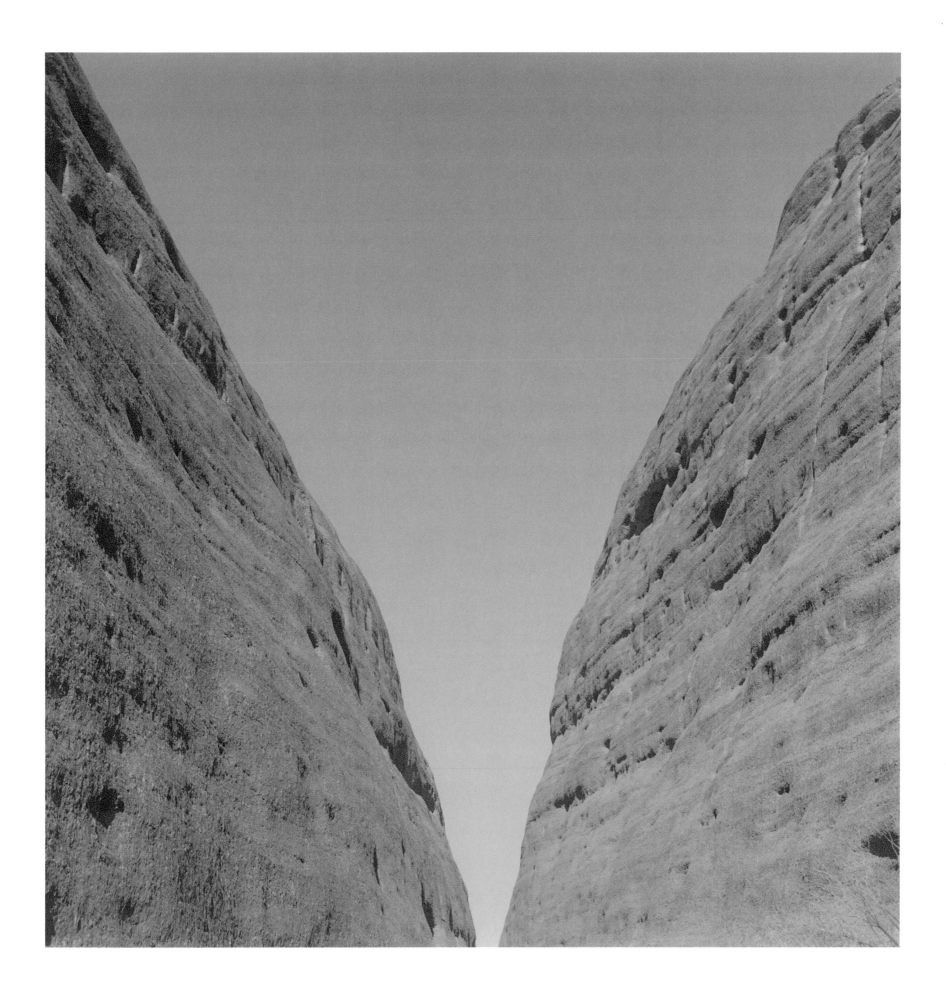

MALINDI, KENYA, 1998

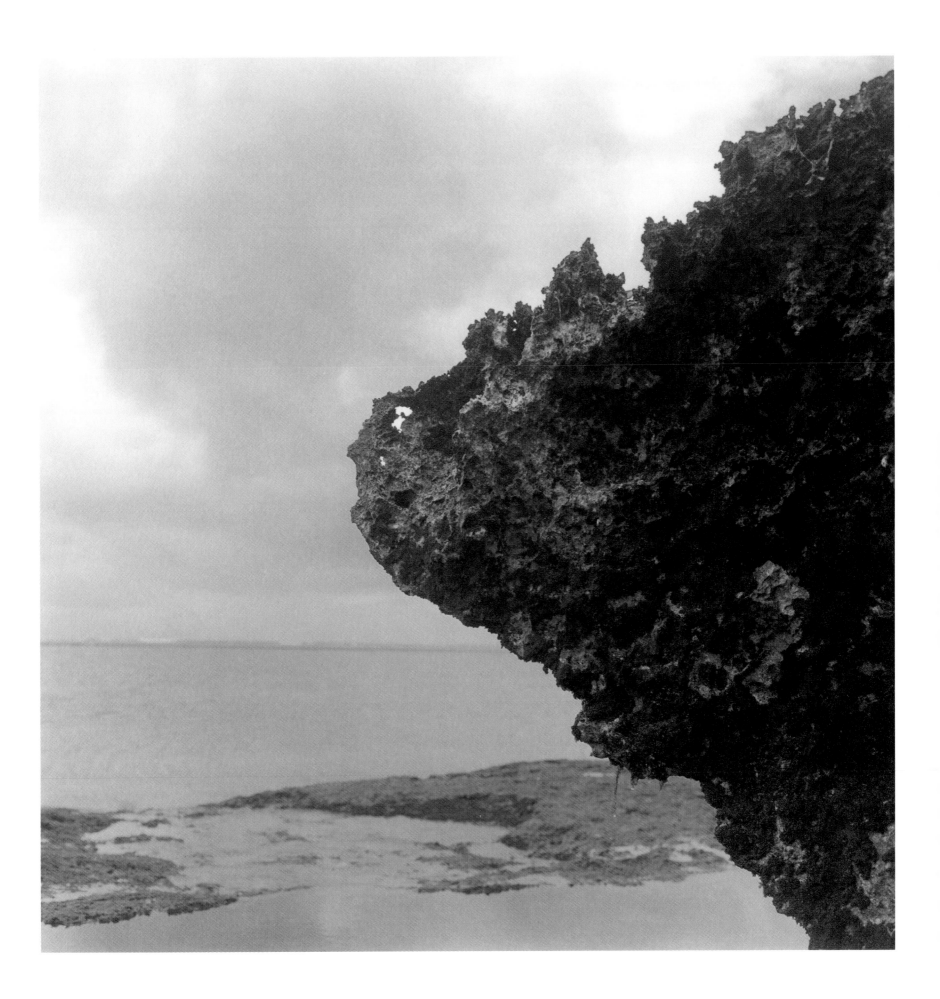

HORSESHOE FALLS, ONTARIO, CANADA, 1992

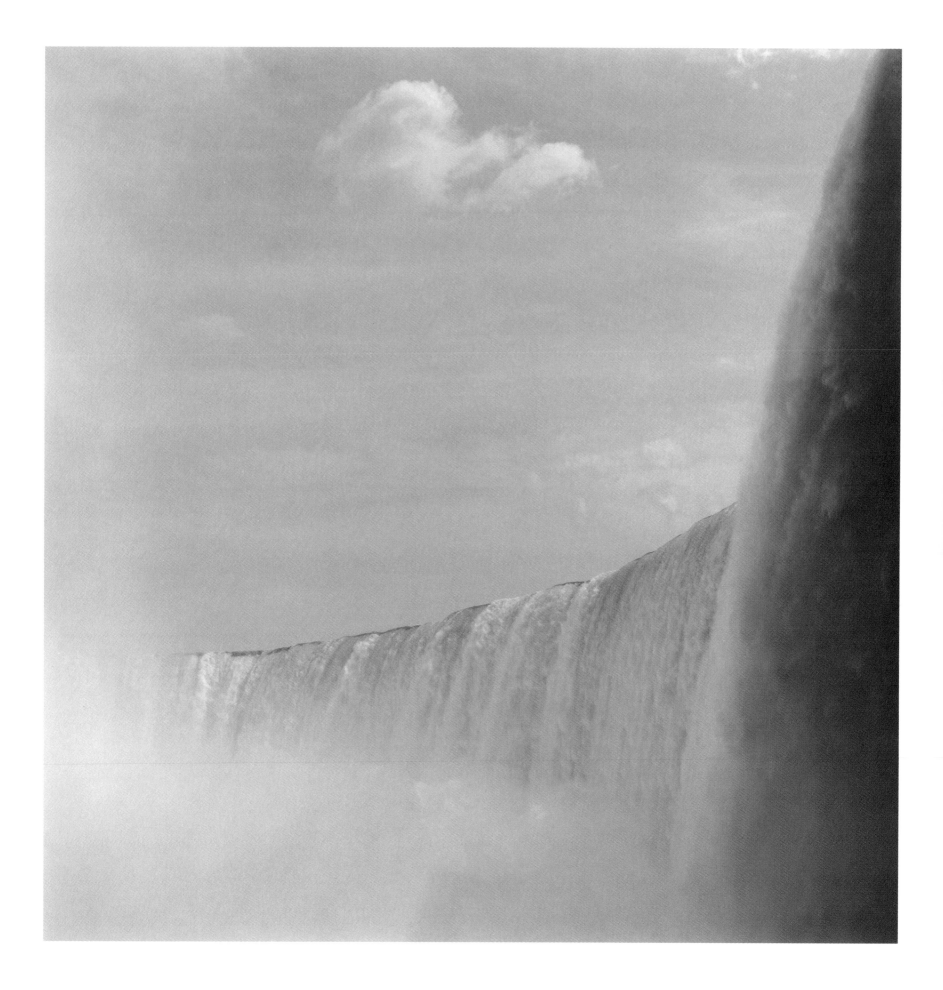

HORSESHOE FALLS, ONTARIO, CANADA, 1992

ARENA EDITIONS
573 WEST SAN FRANCISCO STREET
SANTA FE, NEW MEXICO 87501
USA

g art of our time, with books featuring illuminating essays, exquisite , papers, and bindings. Our commitment is to present the most ect the concerns of contemporary art, society, and culture. For a this card.

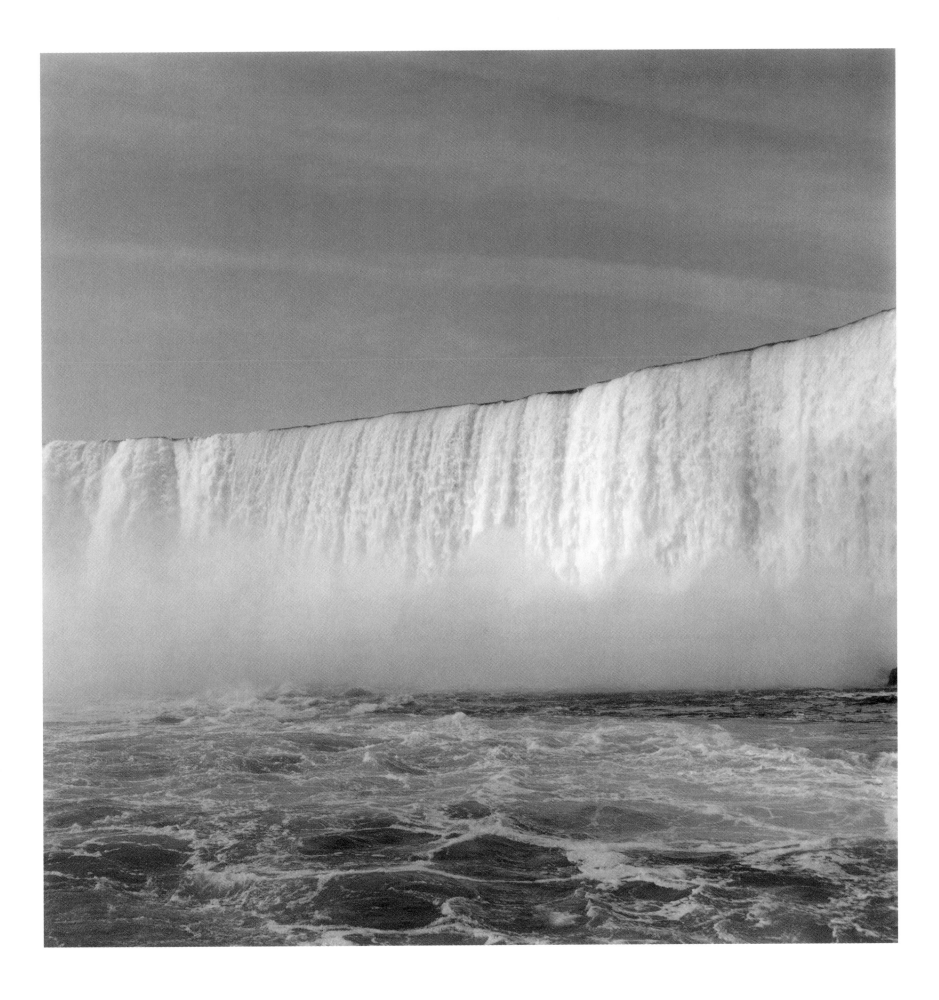

GATE OF ANGKOR THOM, SIEM RIEP, CAMBODIA, 1993

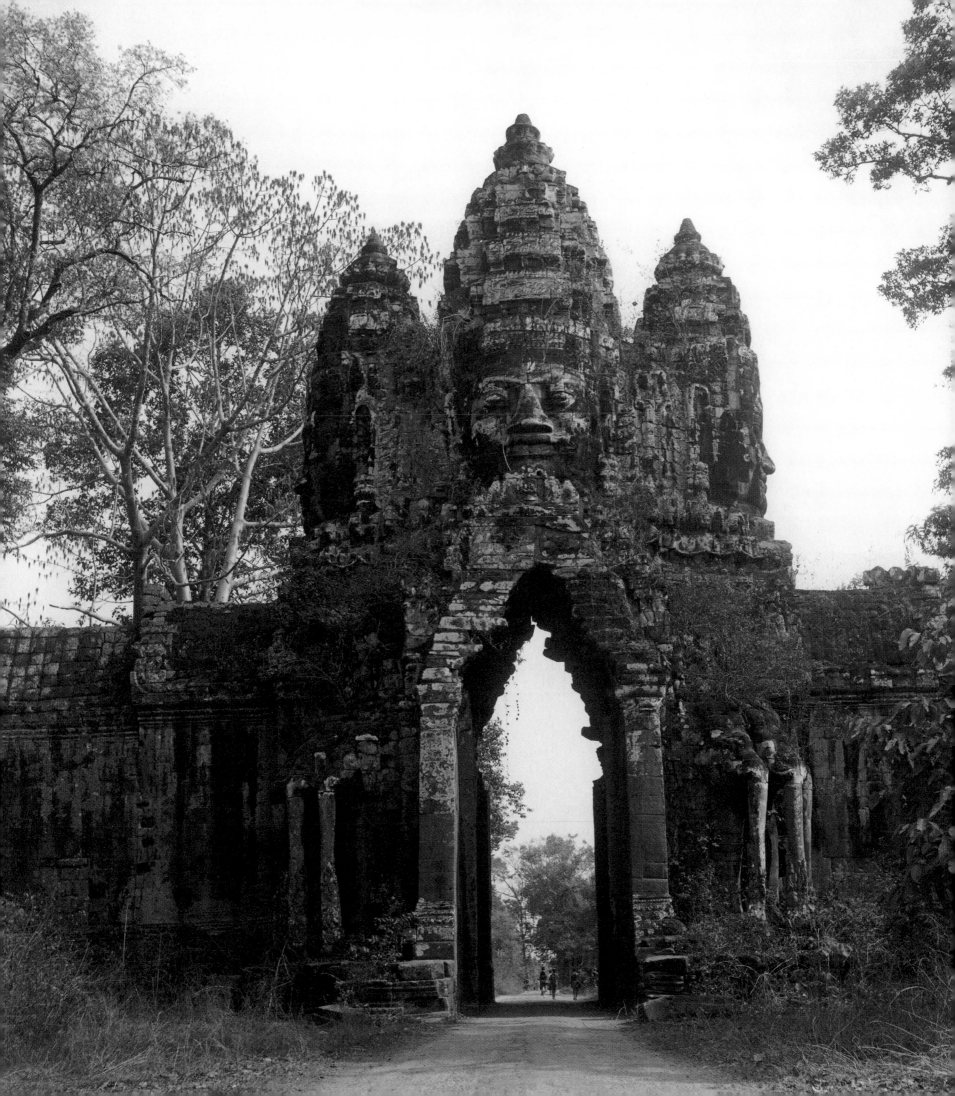

PAGAN, BURMA, 1993

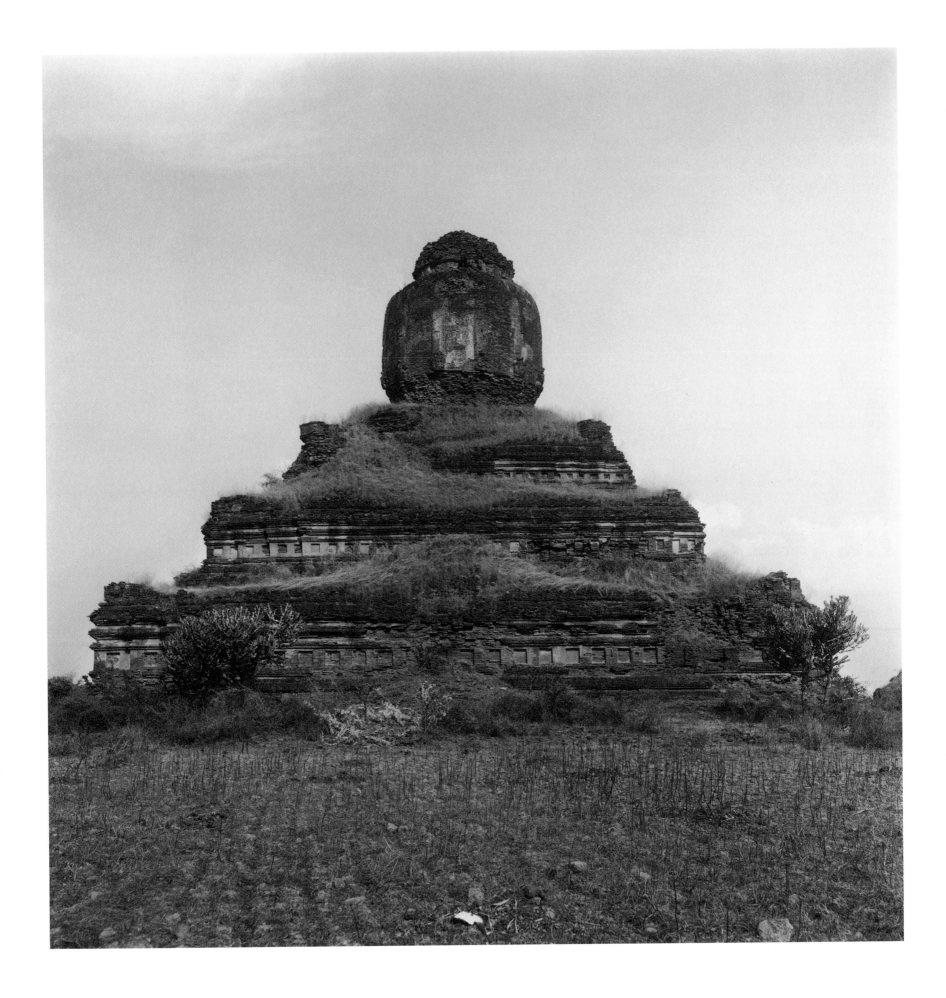

PAGAN, BURMA, 1993

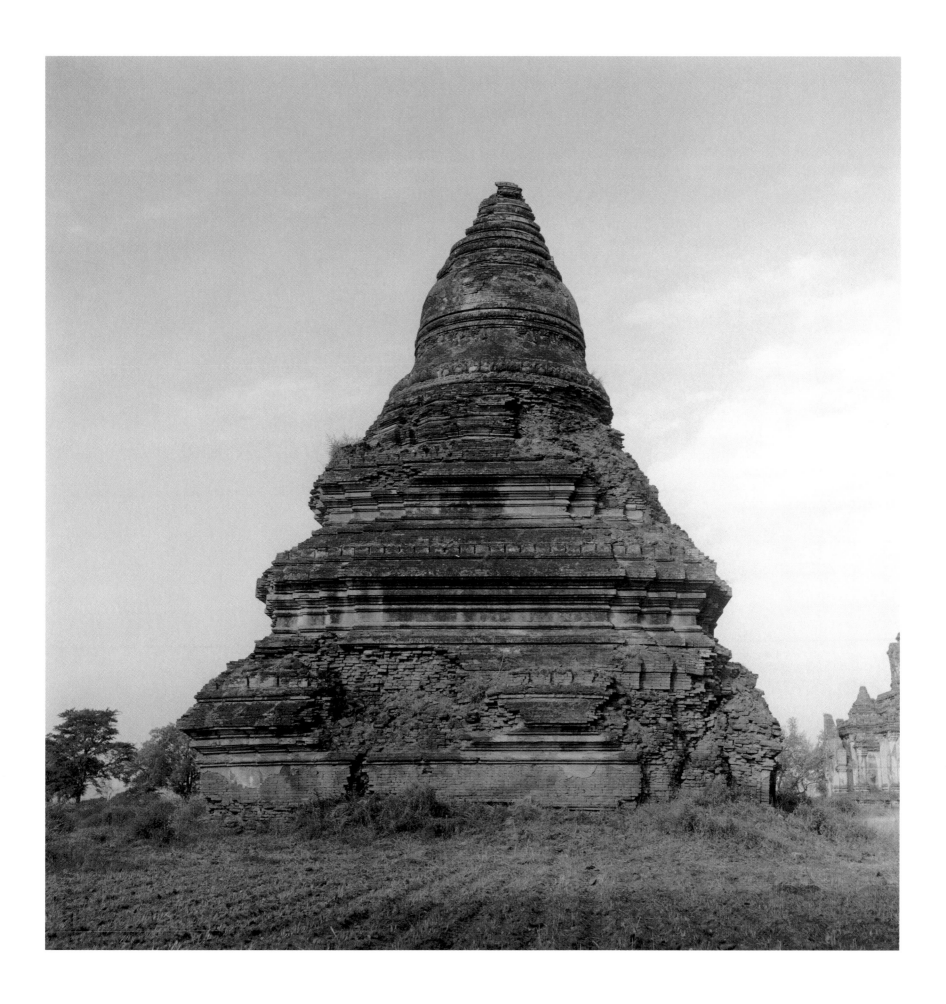

PAGAN, BURMA, 1993

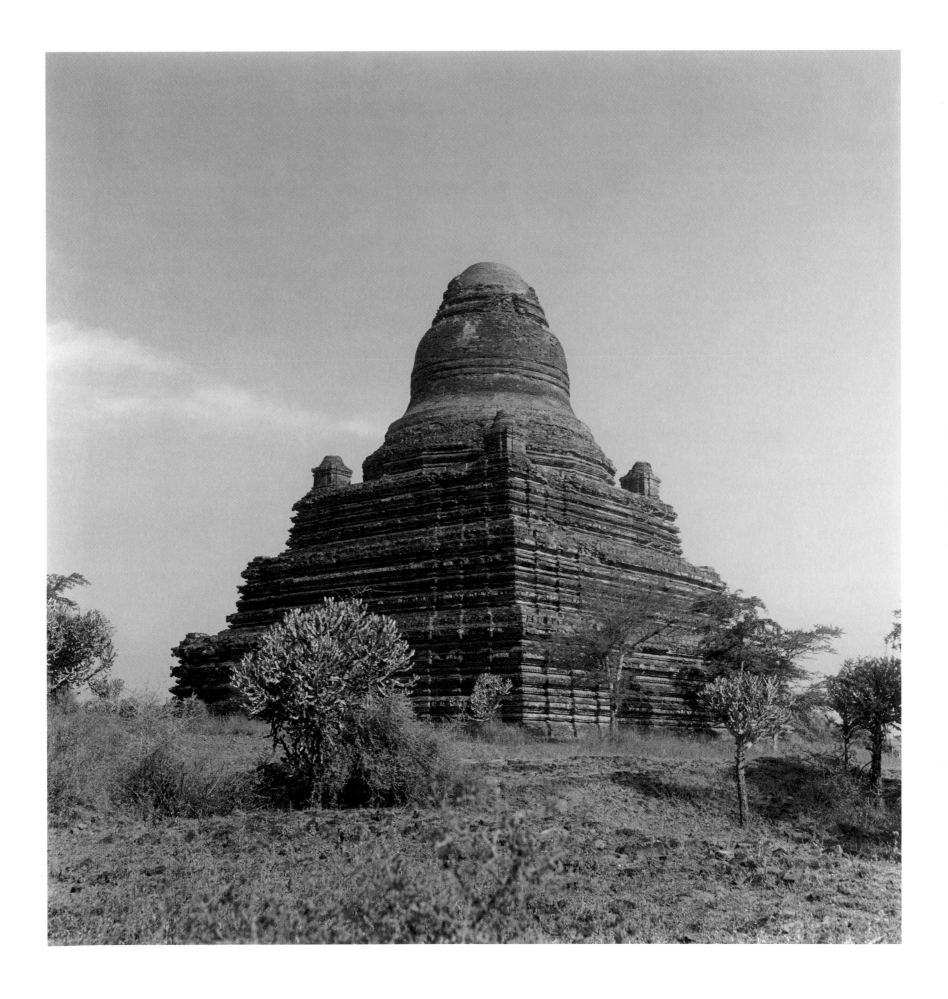

PAGODA, PAGAN, BURMA, 1993

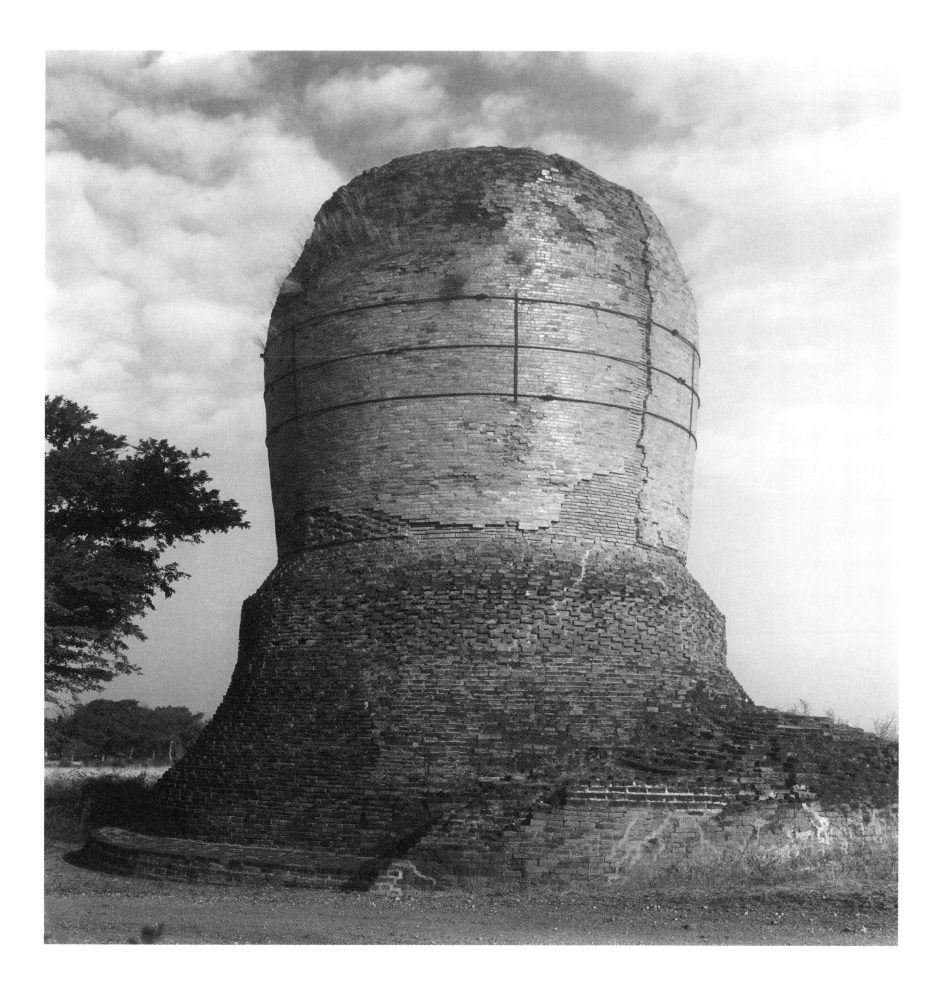

PAGAN, BURMA, 1993

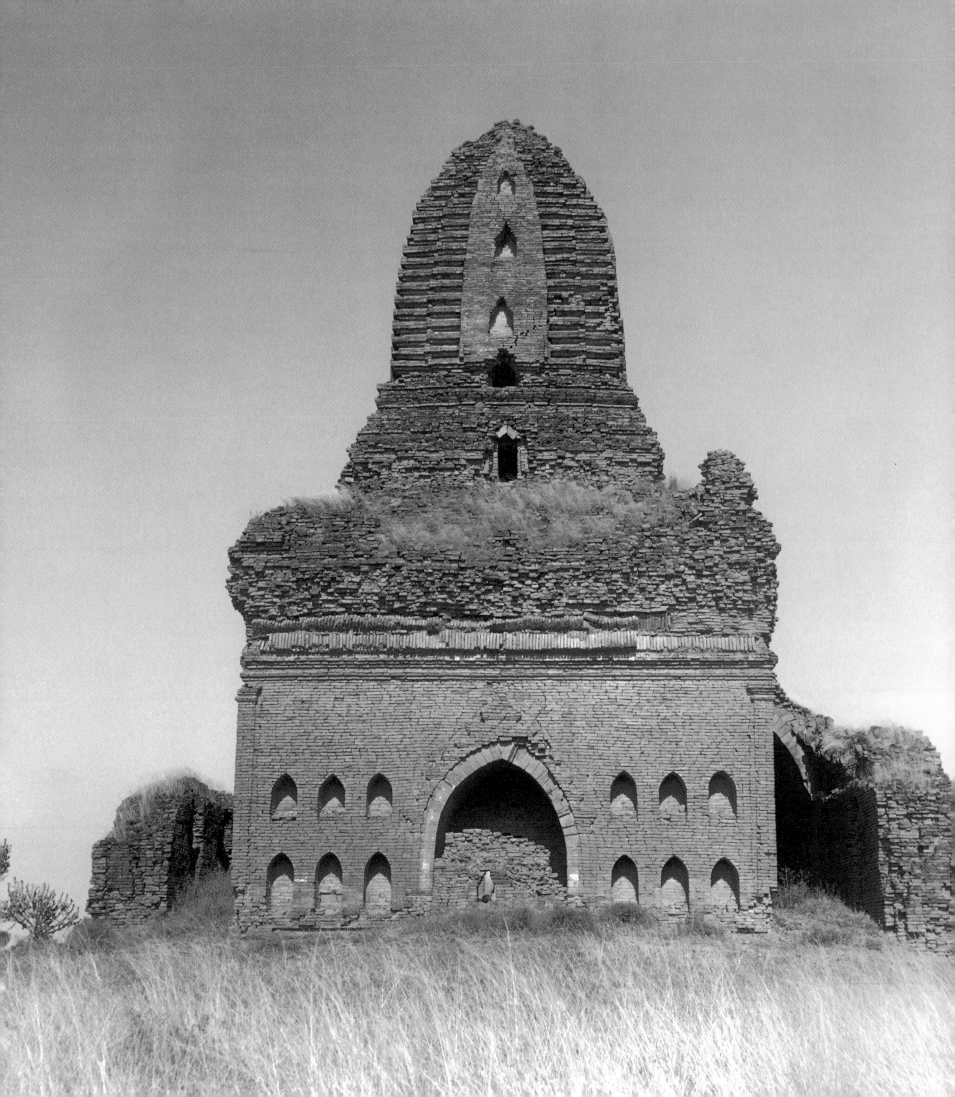

MOPTI, MALI, 1997

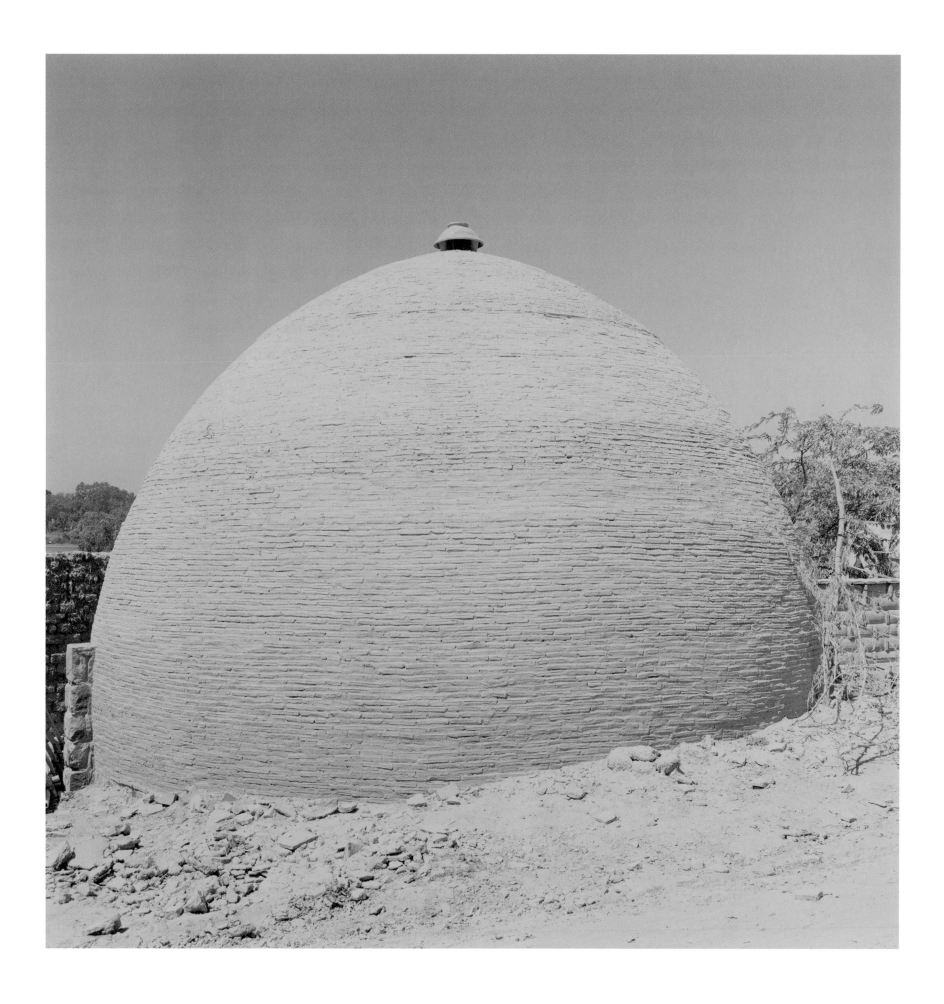

LIBRARY, PAGAN, BURMA, 1993

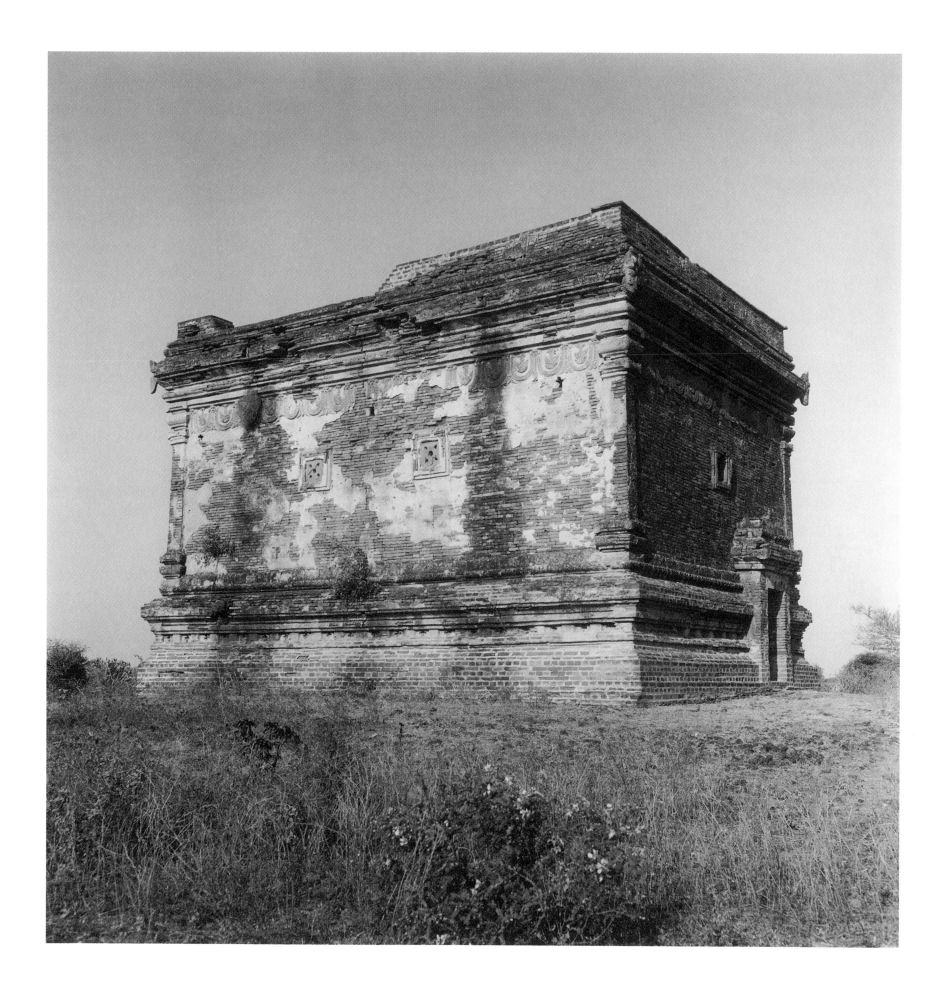

THE BAYON, ANGKOR WAT, CAMBODIA, 1993

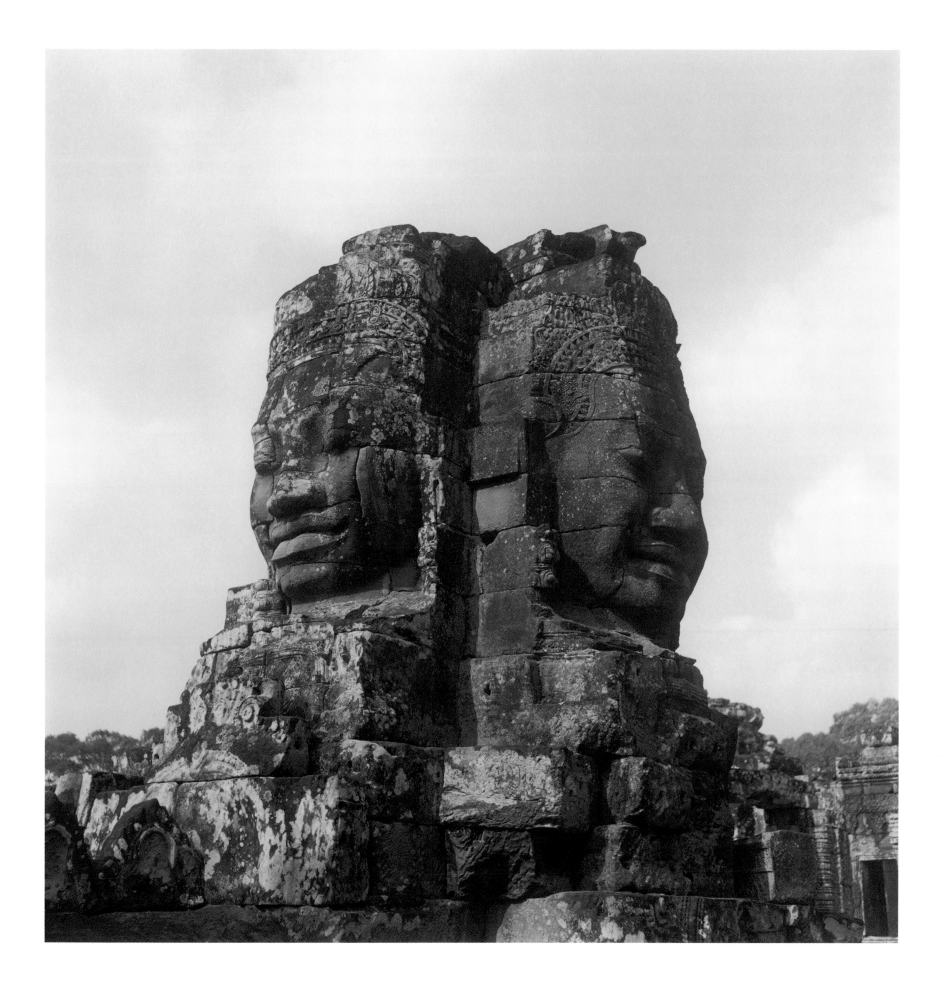

THE GUARDIANS, ANGKOR THOM, ANGKOR WAT, CAMBODIA, 1993

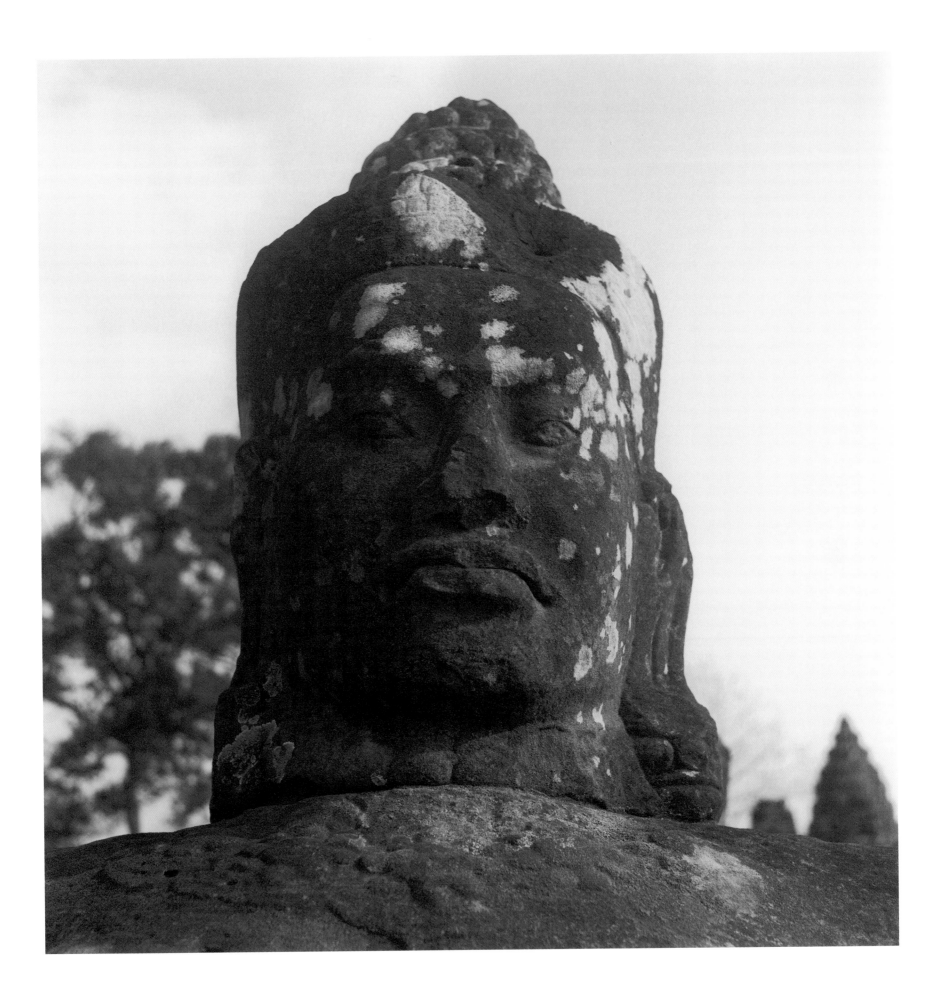

BUDDHA, SUKHOTHAI, THAILAND, 1993

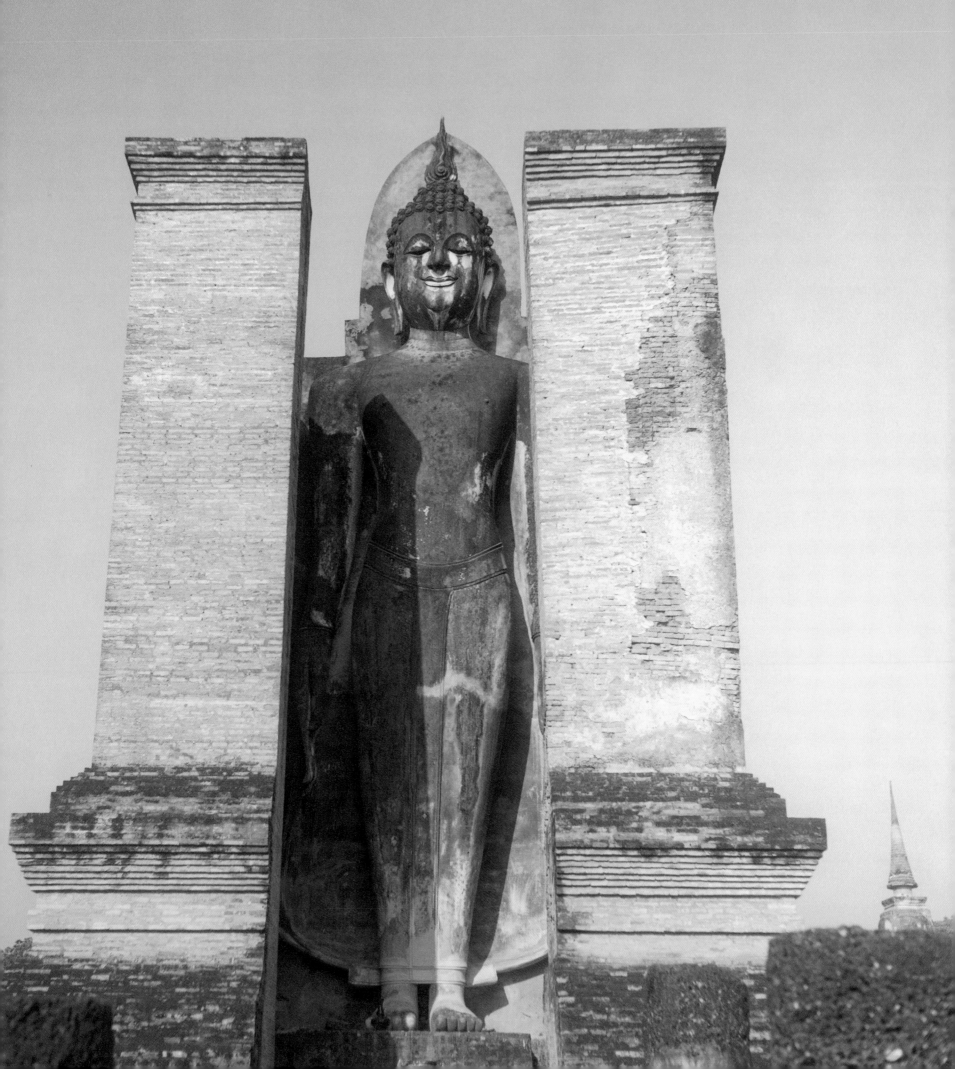

WALKING BUDDHA, SUKHOTHAI, THAILAND, 1993

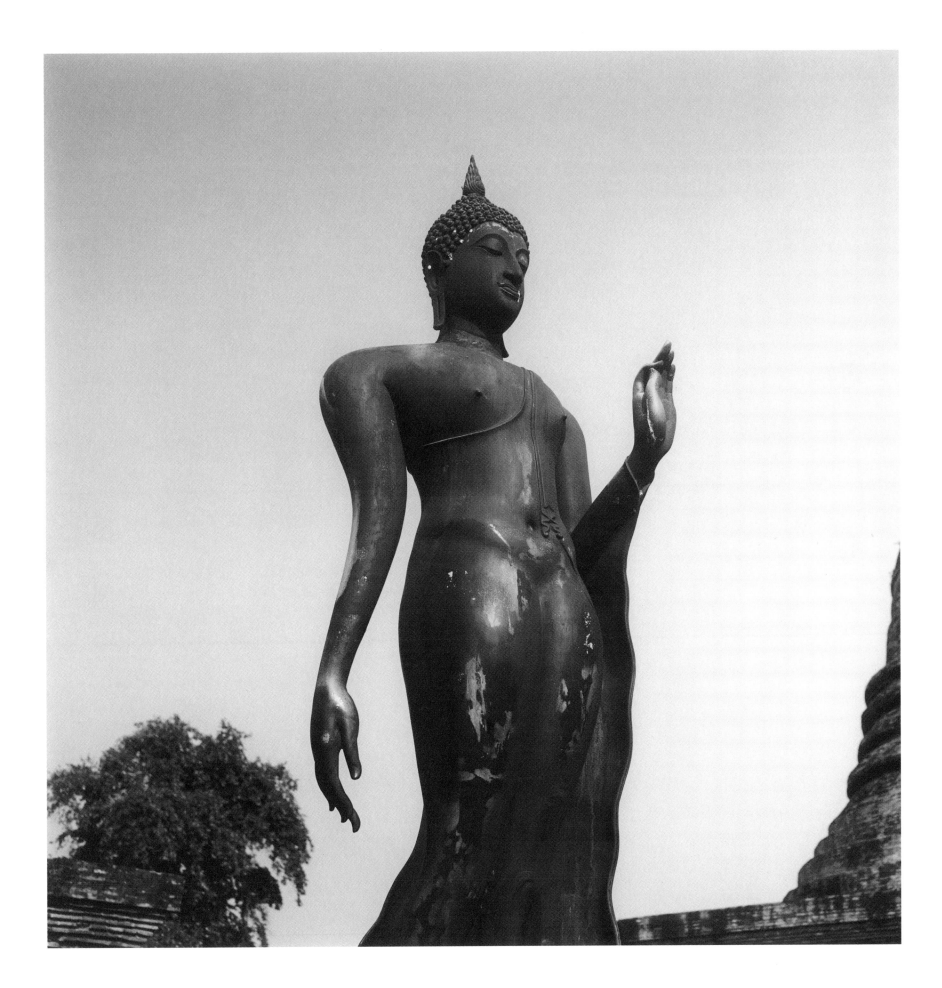

THE BAYON, ANGKOR WAT, CAMBODIA, 1993

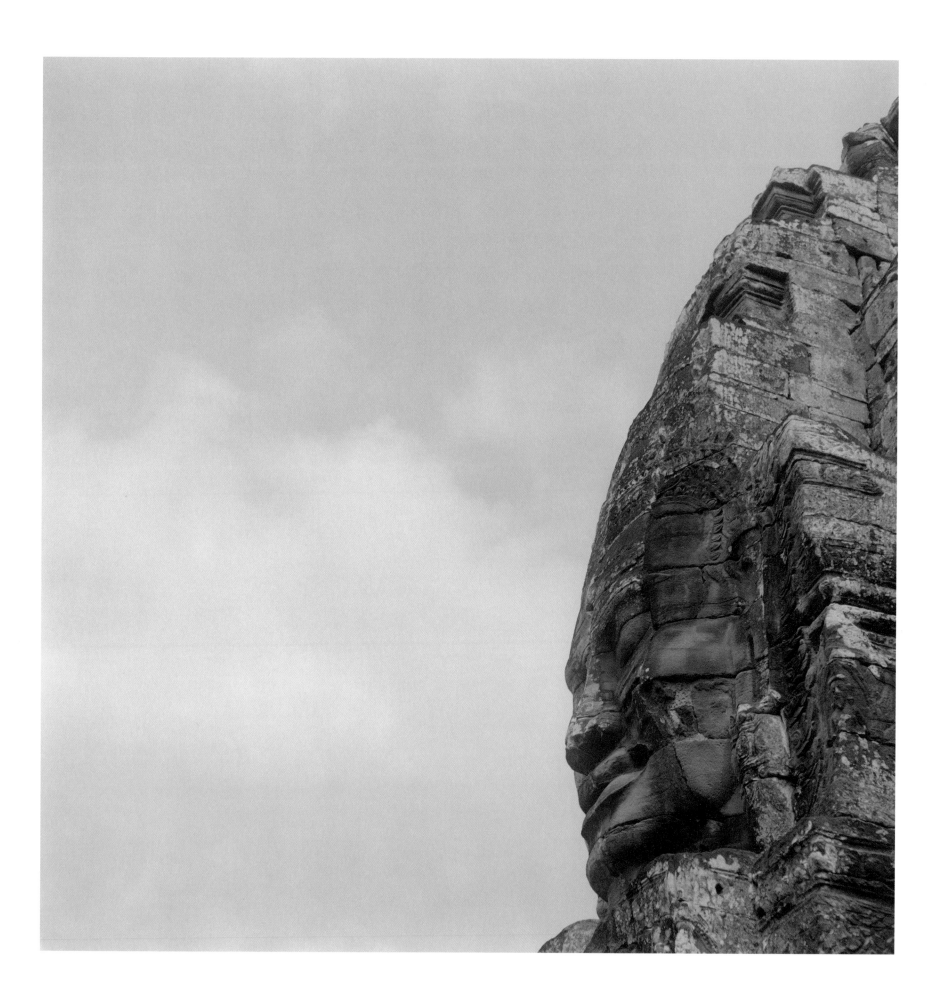

BELL TOWER, MOMBASA, KENYA, 1997

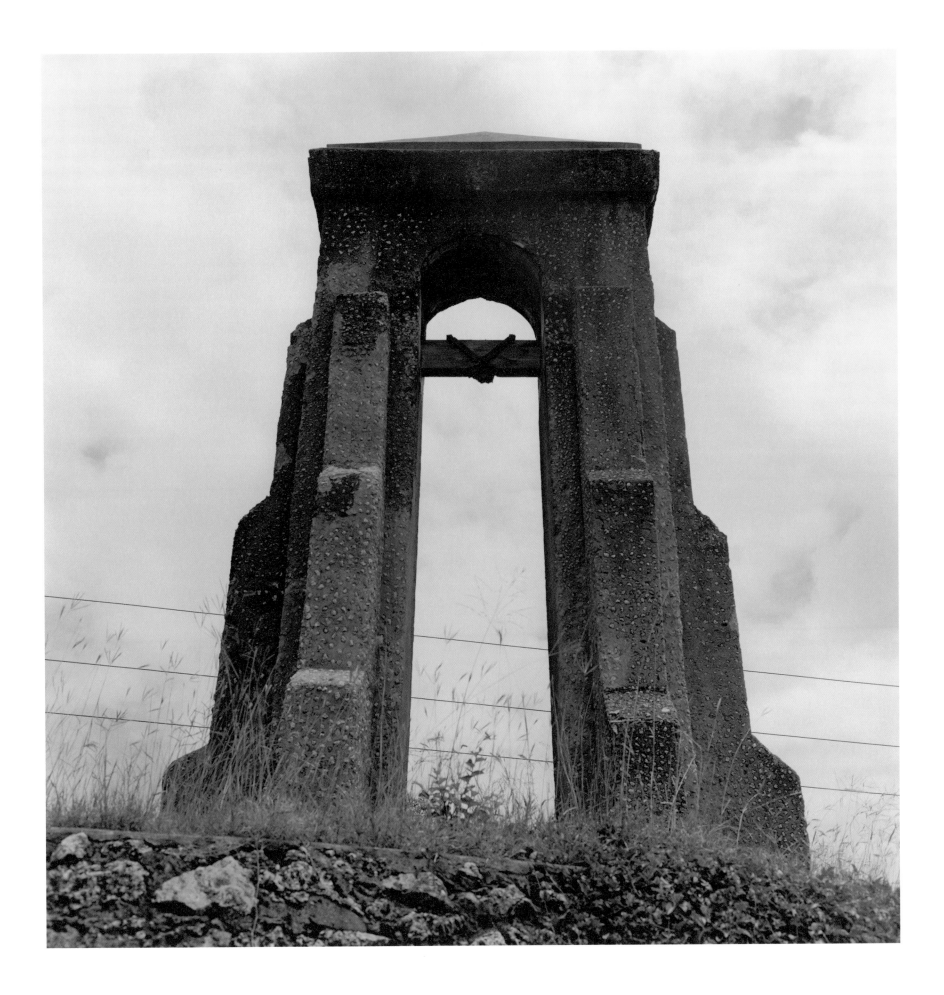

RUIN ON THE APPIA ANTICA, ROME, 1993

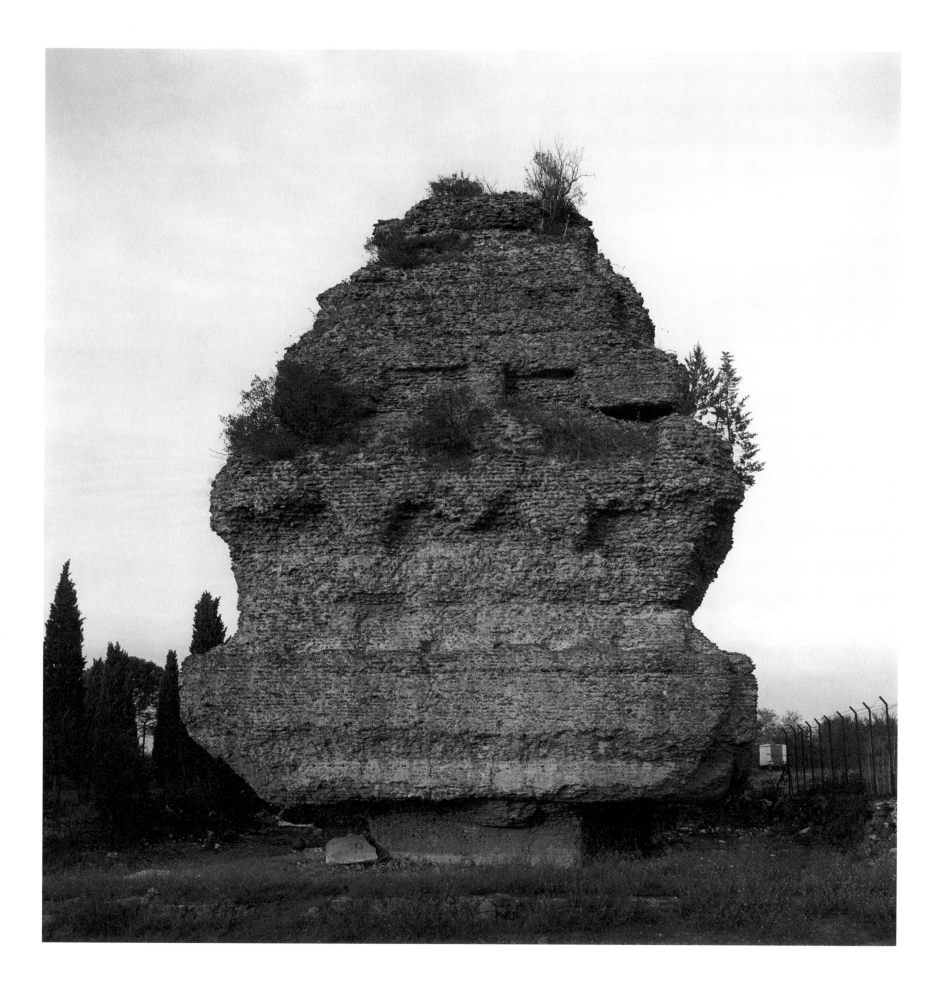

RUIN ON THE APPIA ANTICA, ROME, 1993

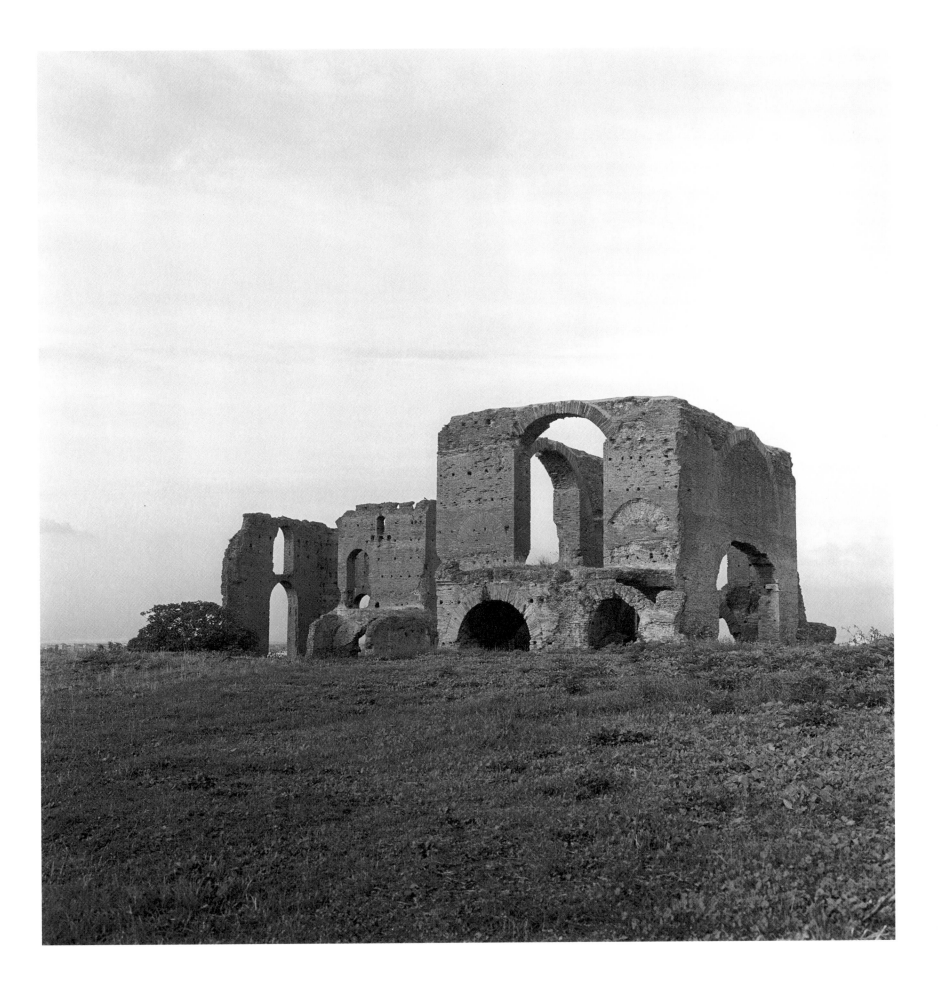

DIDYMA, TURKEY, 1995

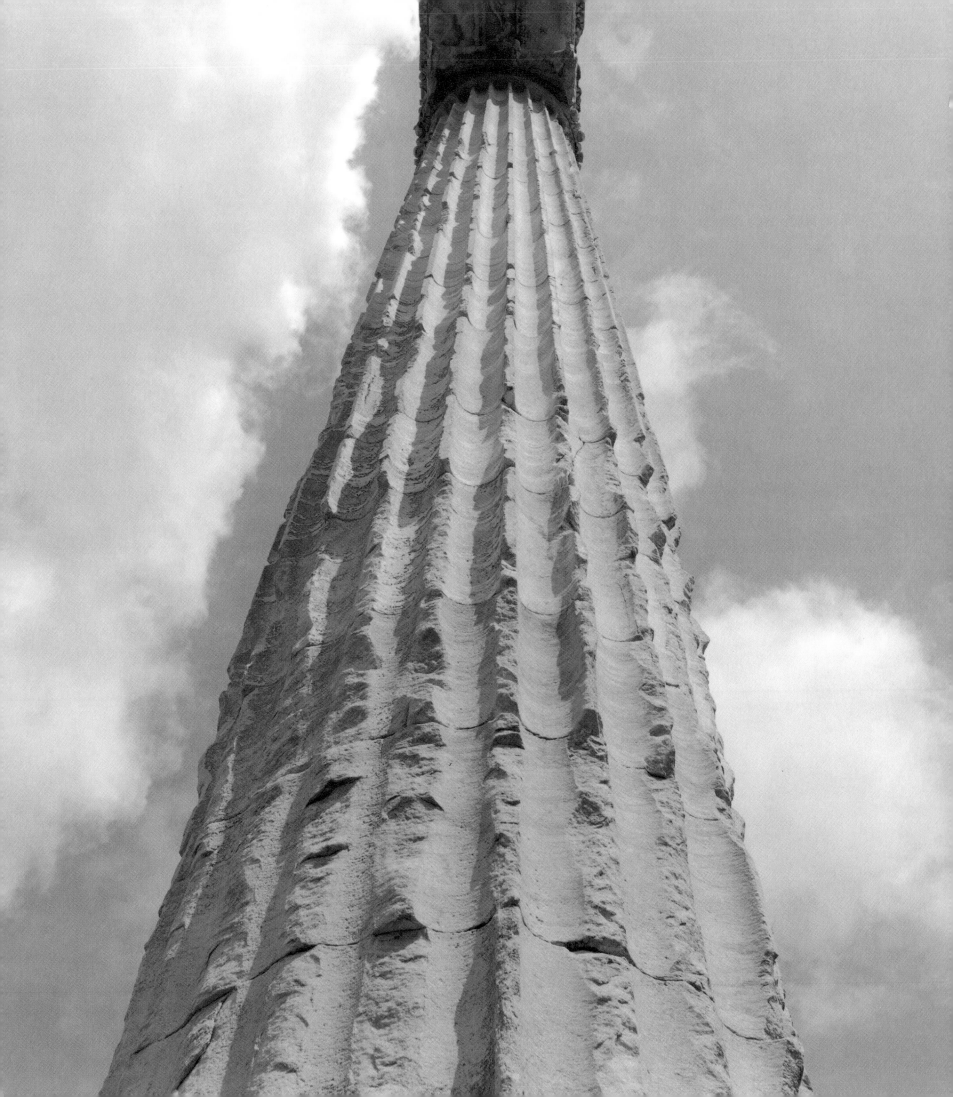

APAMEA, SYRIA, 1995

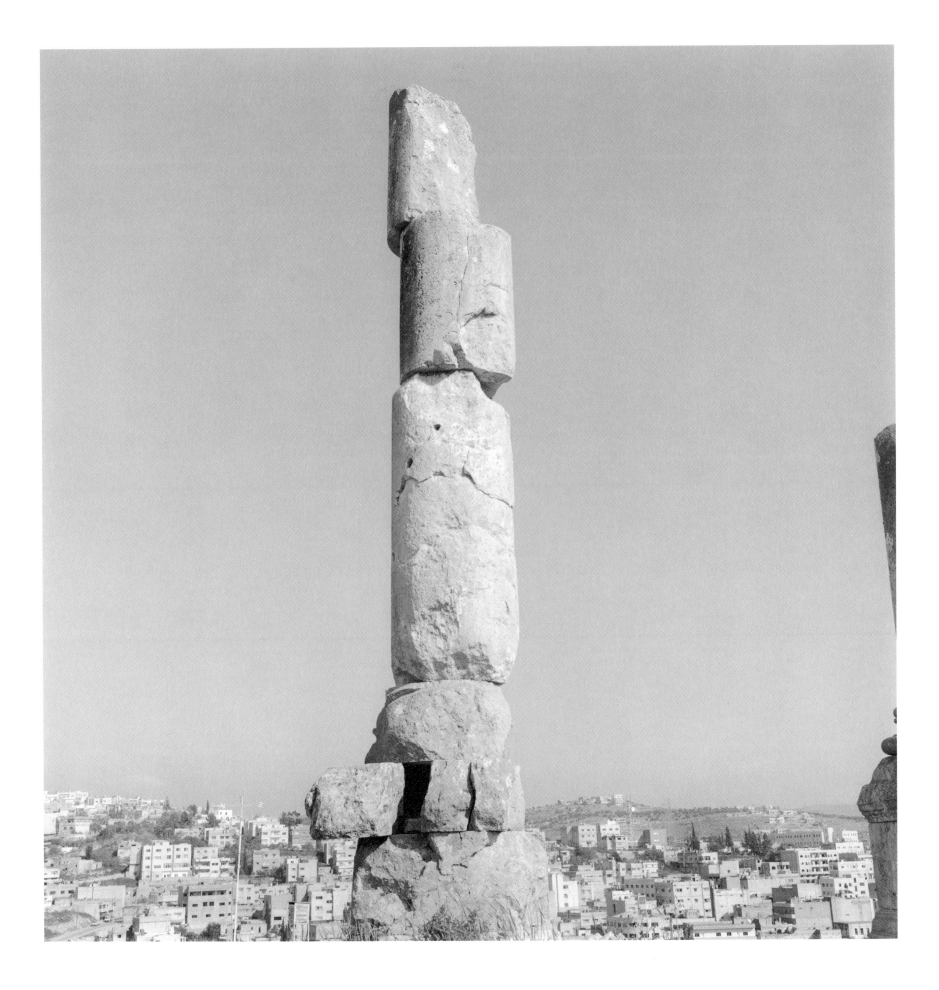

TETRAPYLON, PALMYRA, SYRIA, 1995

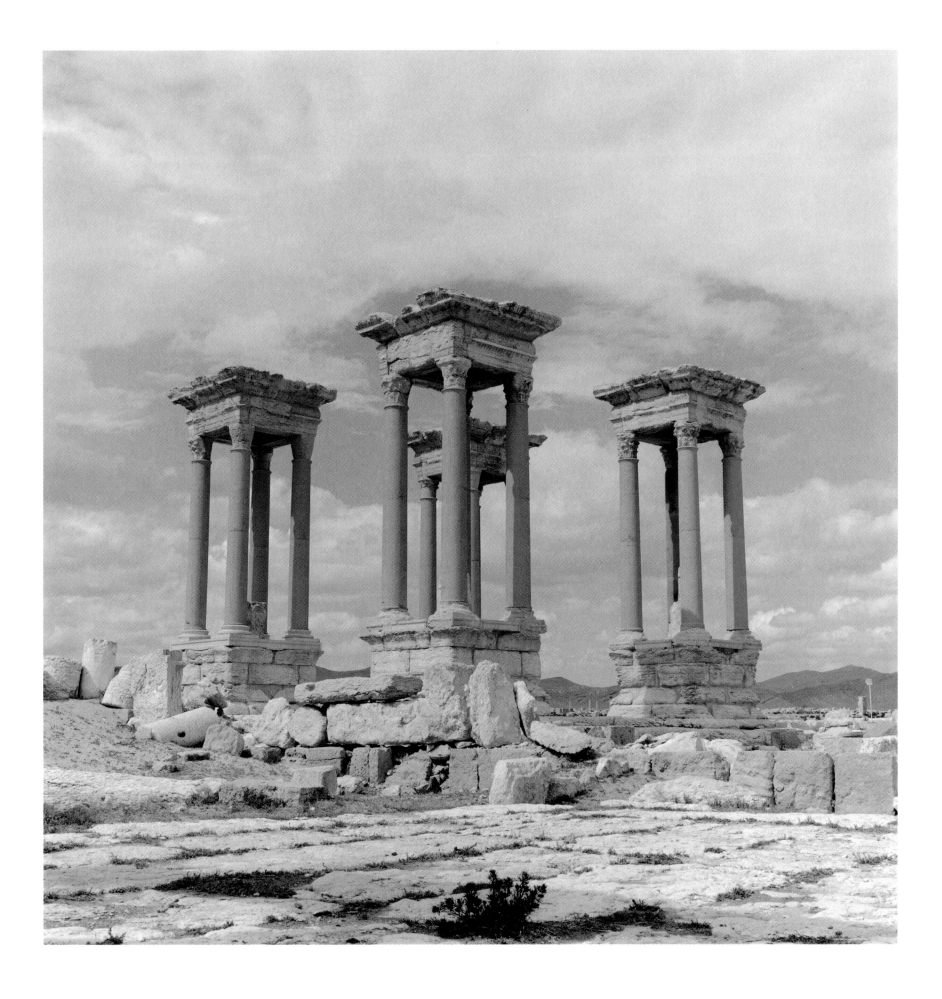

KHARANAH CASTLE, QASR-AL KHARANAH, JORDAN, 1995

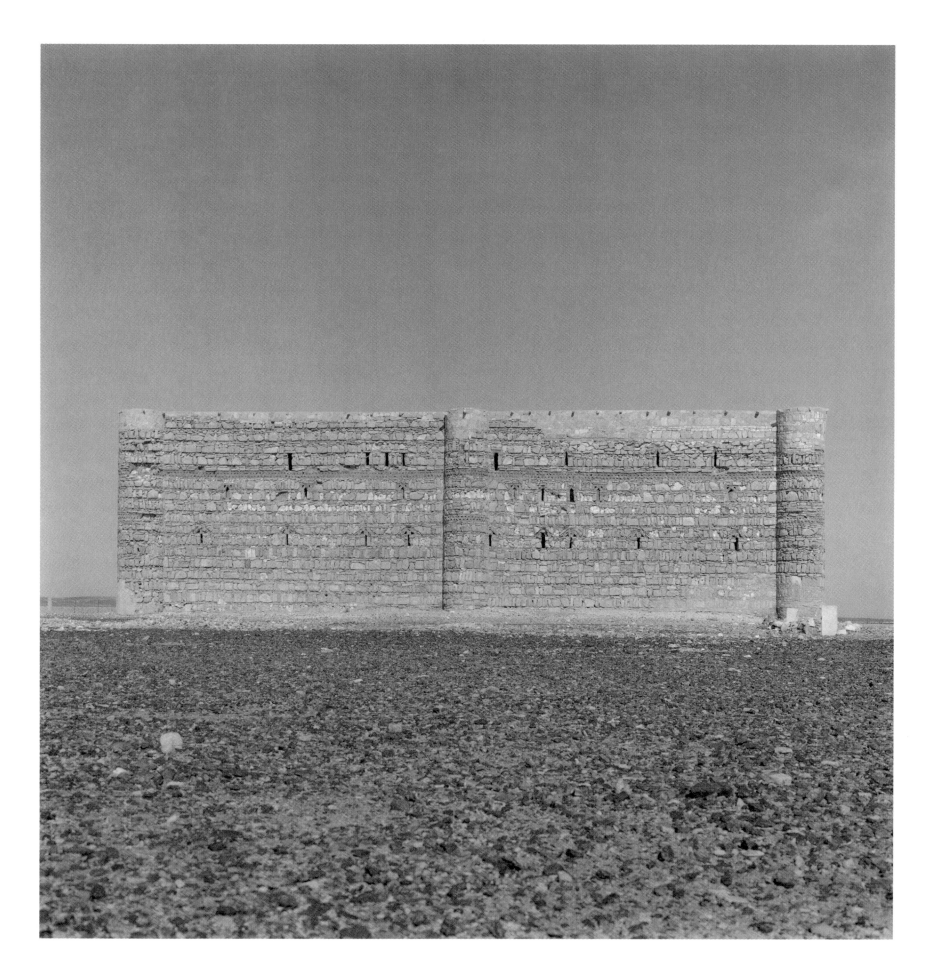

TOMB, PALMYRA, SYRIA, 1995

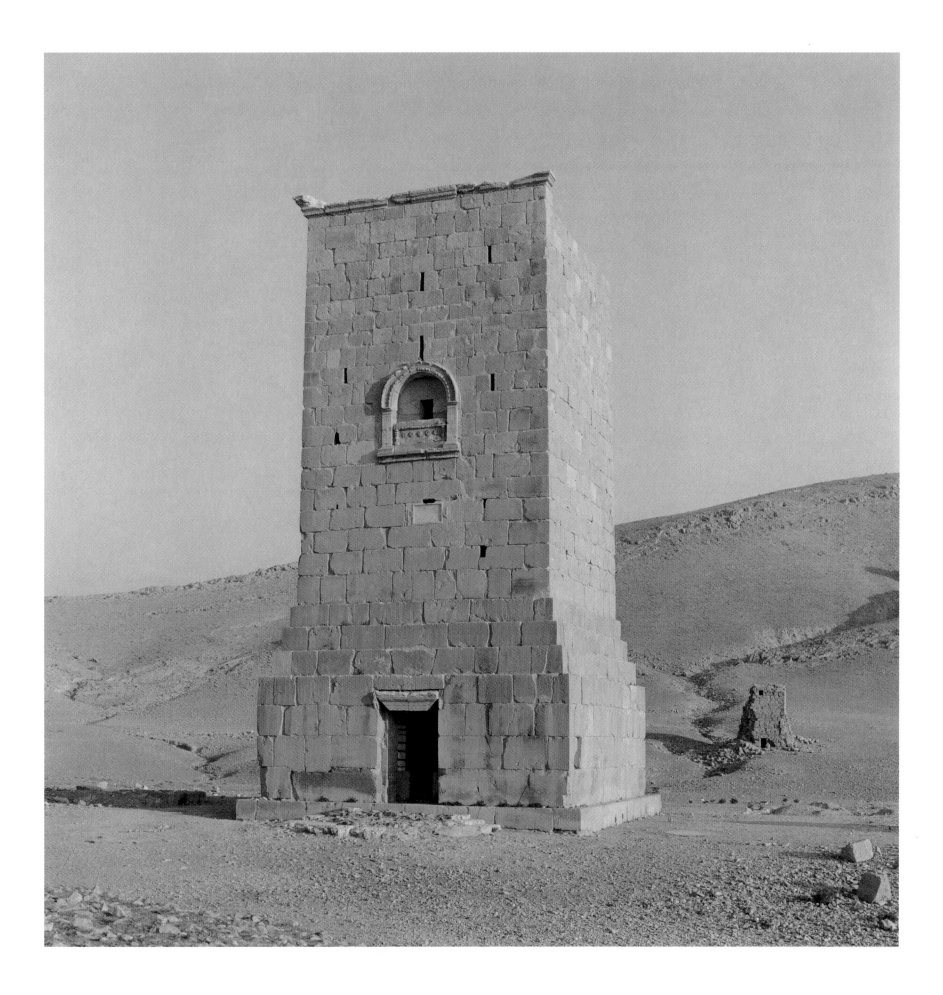

ST. GEORGE'S CHURCH, LALIBELA, ETHIOPIA, 1997

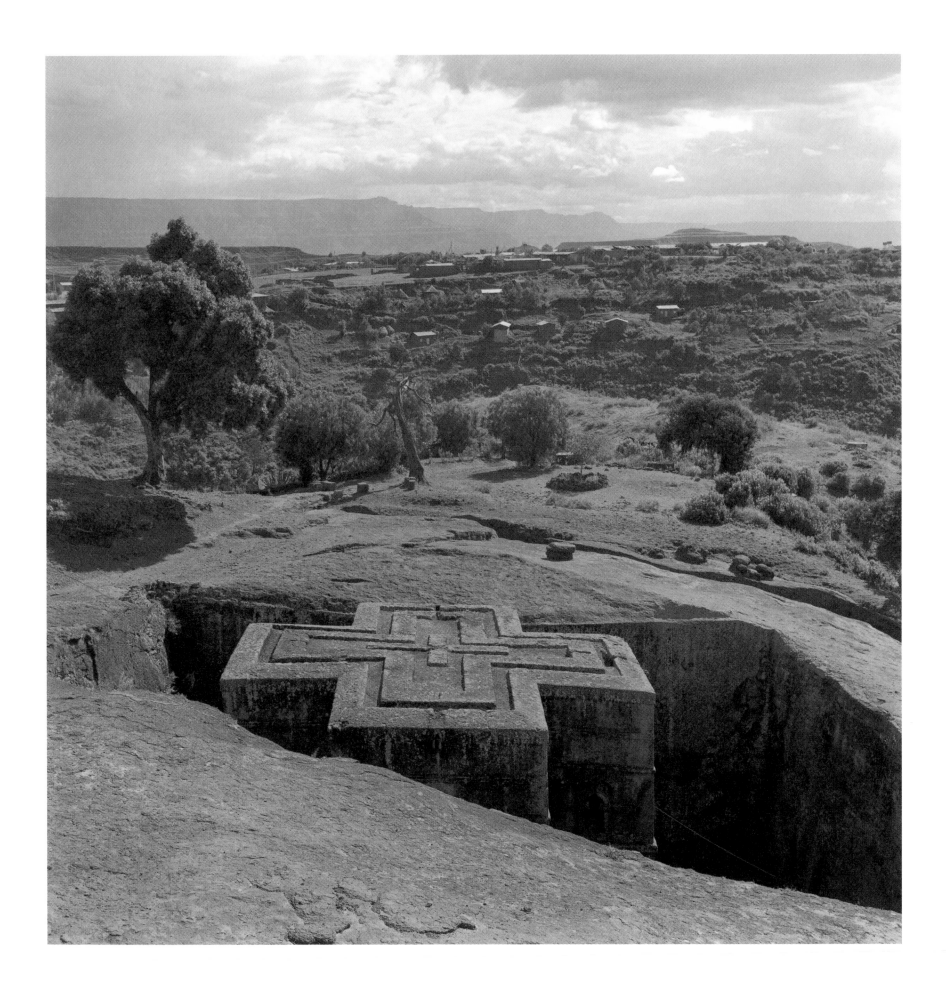

TOMB, PETRA, JORDAN, 1995

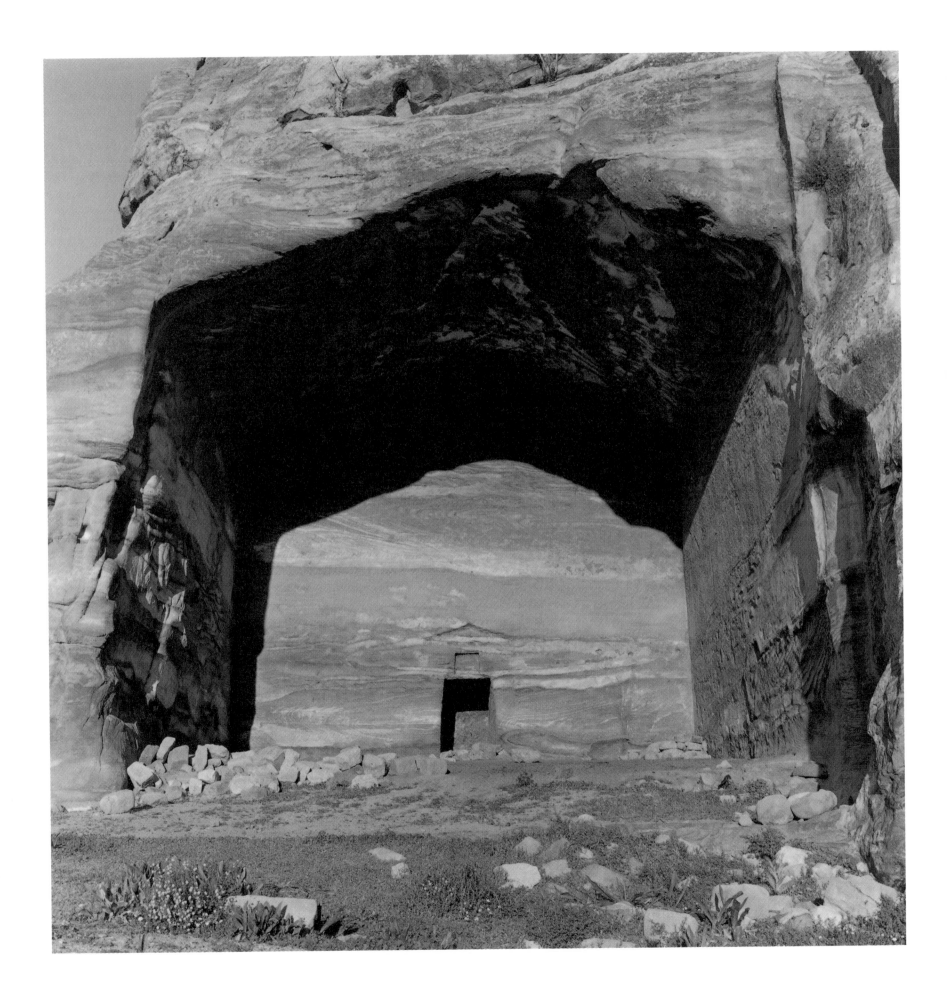

GREAT ZIMBABWE, 1997

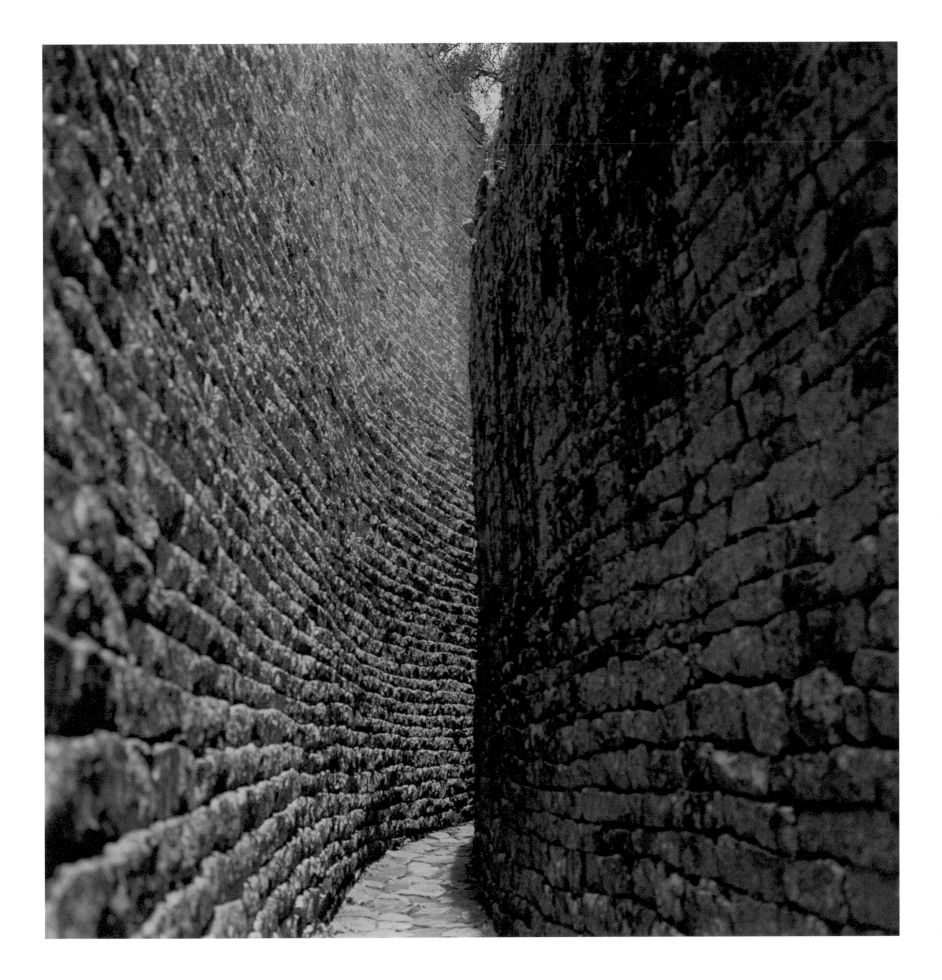

UPTHRUST, PALMYRA, SYRIA, 1995

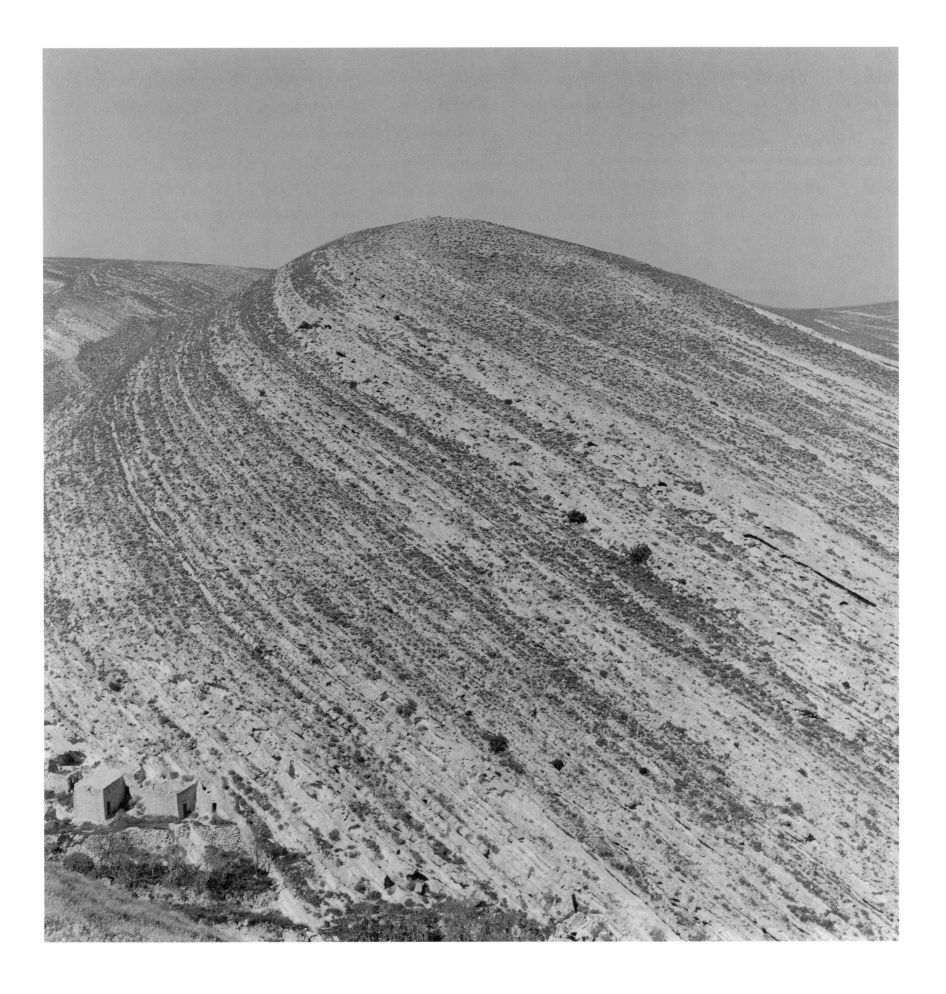

CAPPADOCIA, TURKEY, 1995

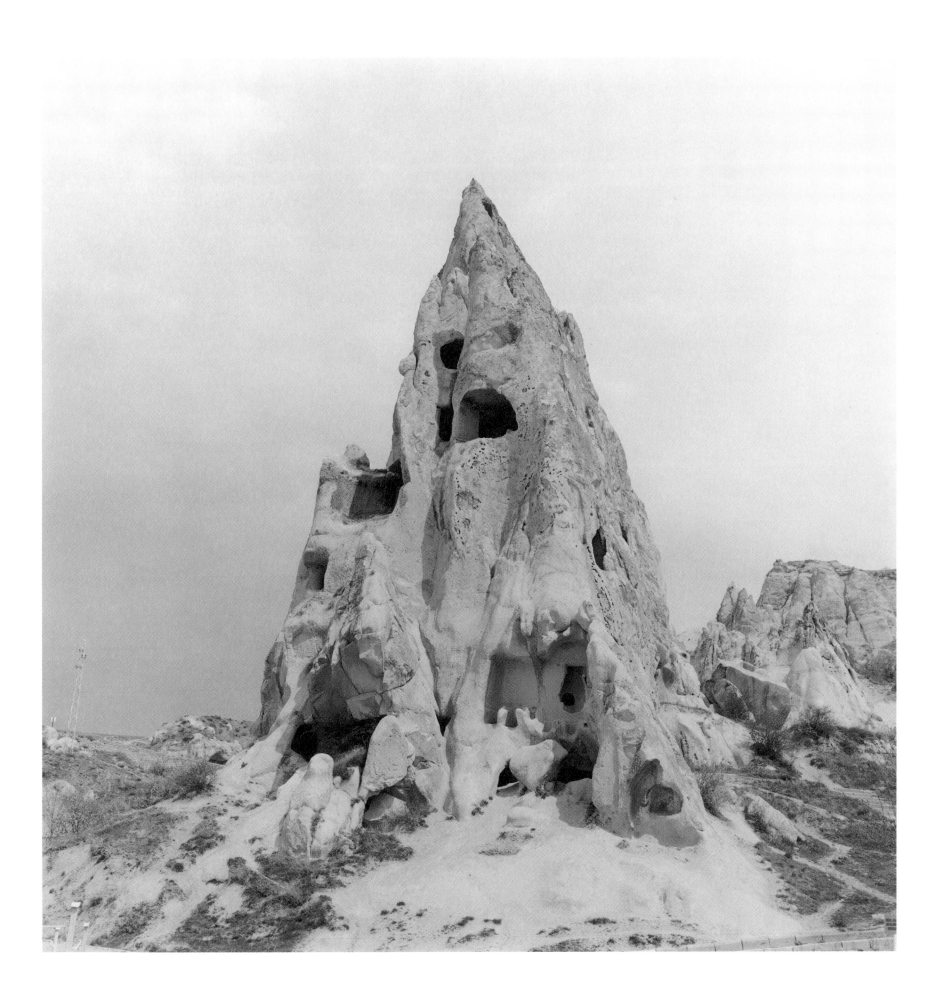

TEMPLE, PALMYRA, SYRIA, 1995

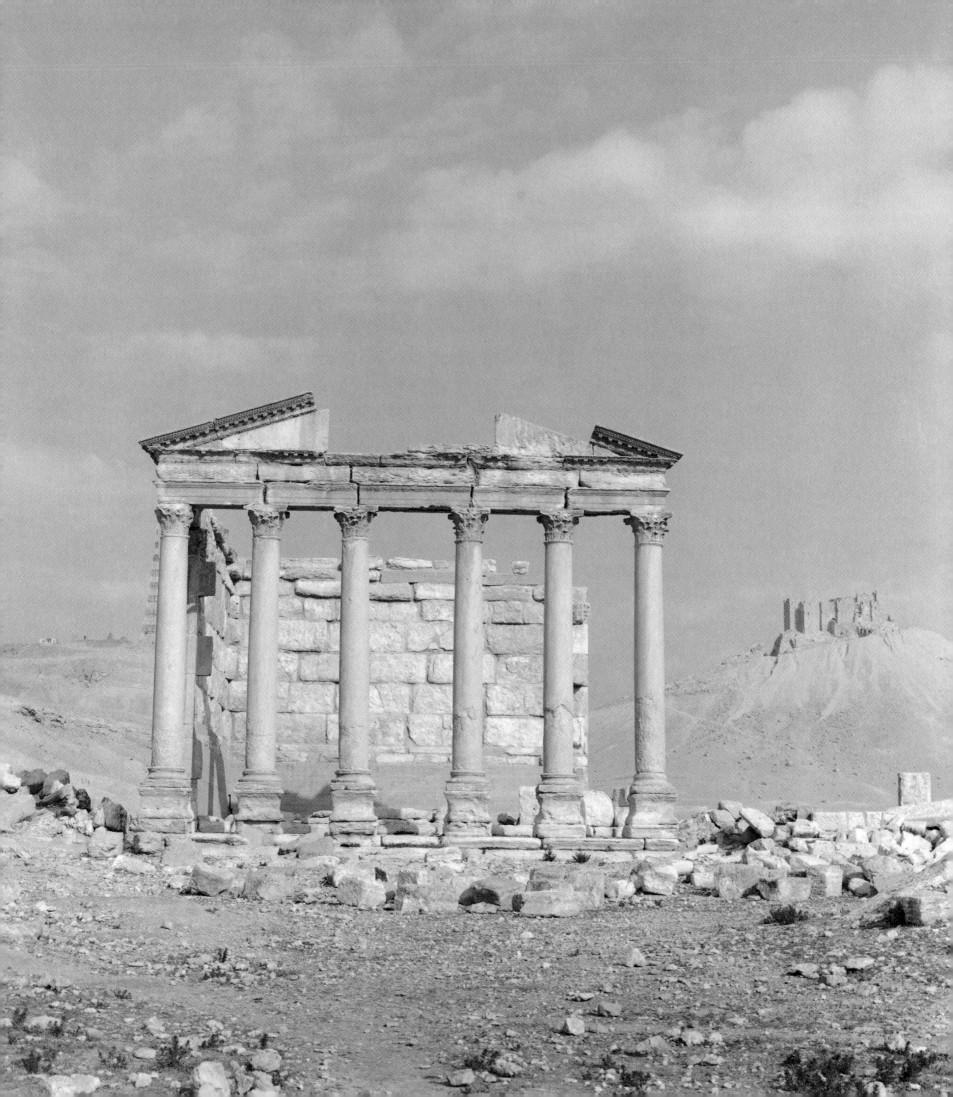

APAMEA, SYRIA, 1995

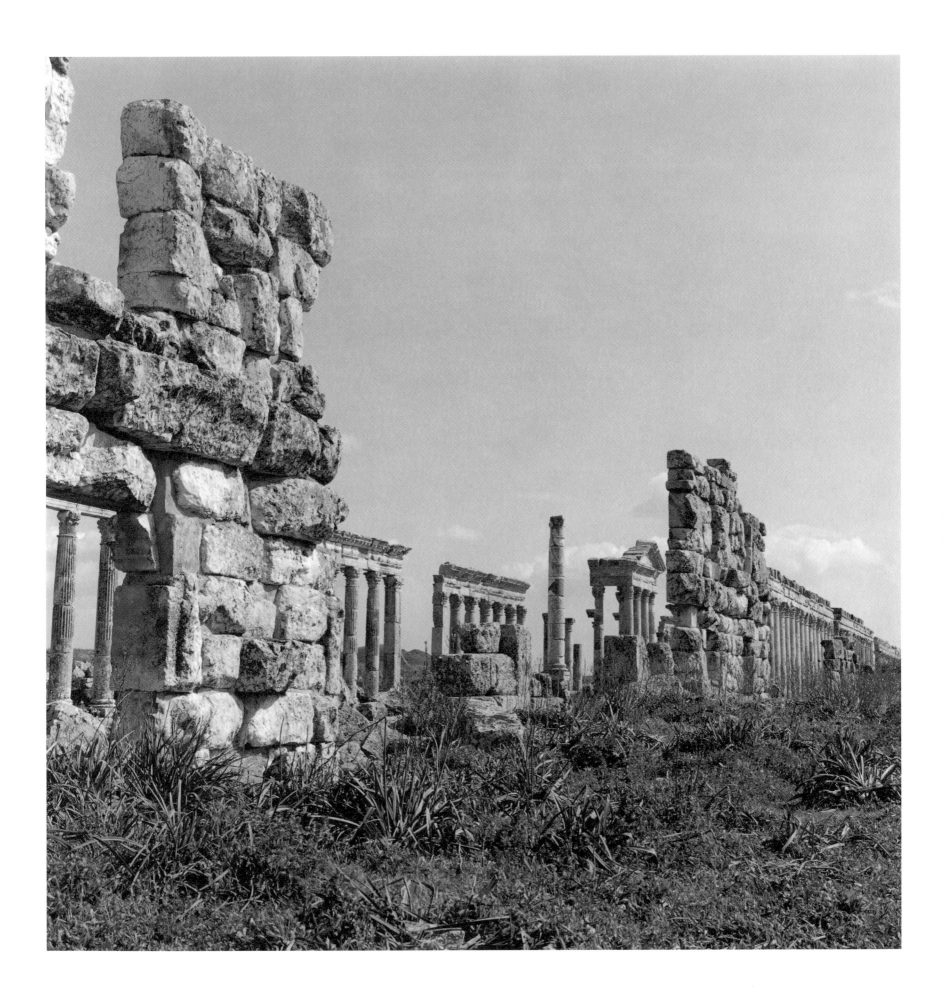

TOMB, PALMYRA, SYRIA, 1995

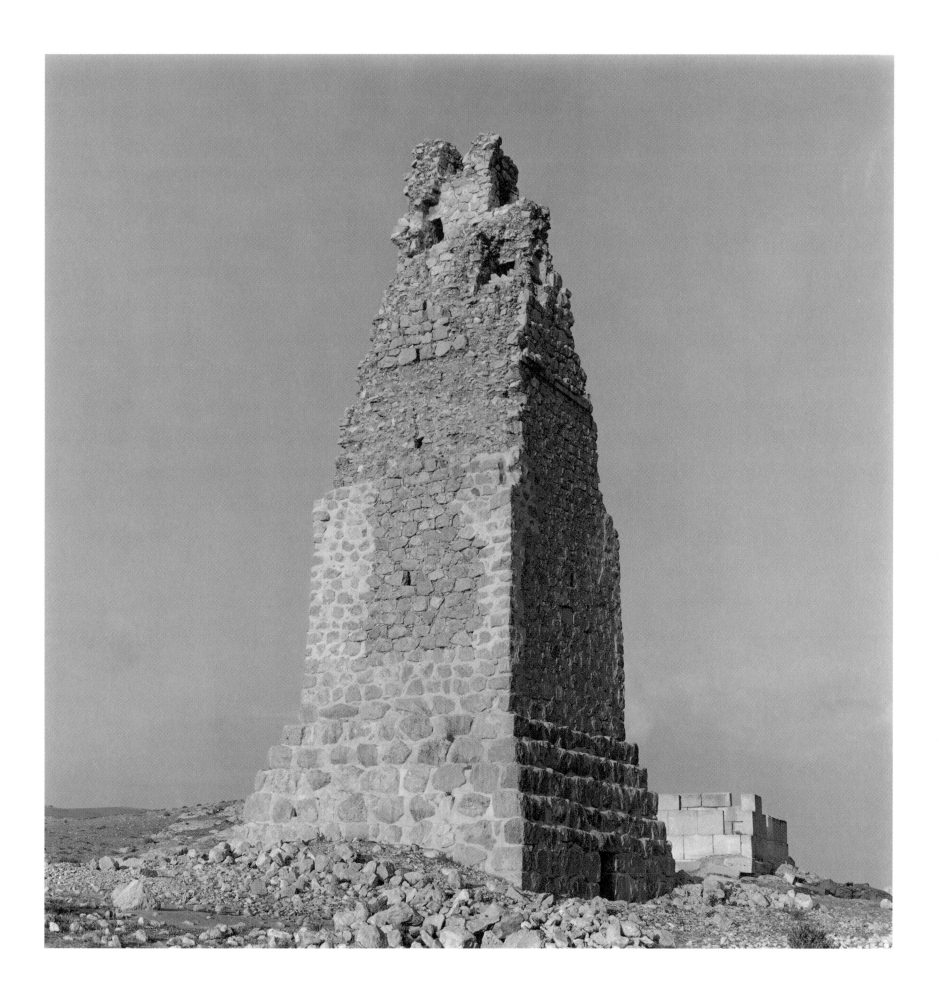

TEMPLE OF AWAM, MARIB, YEMEN, 1996

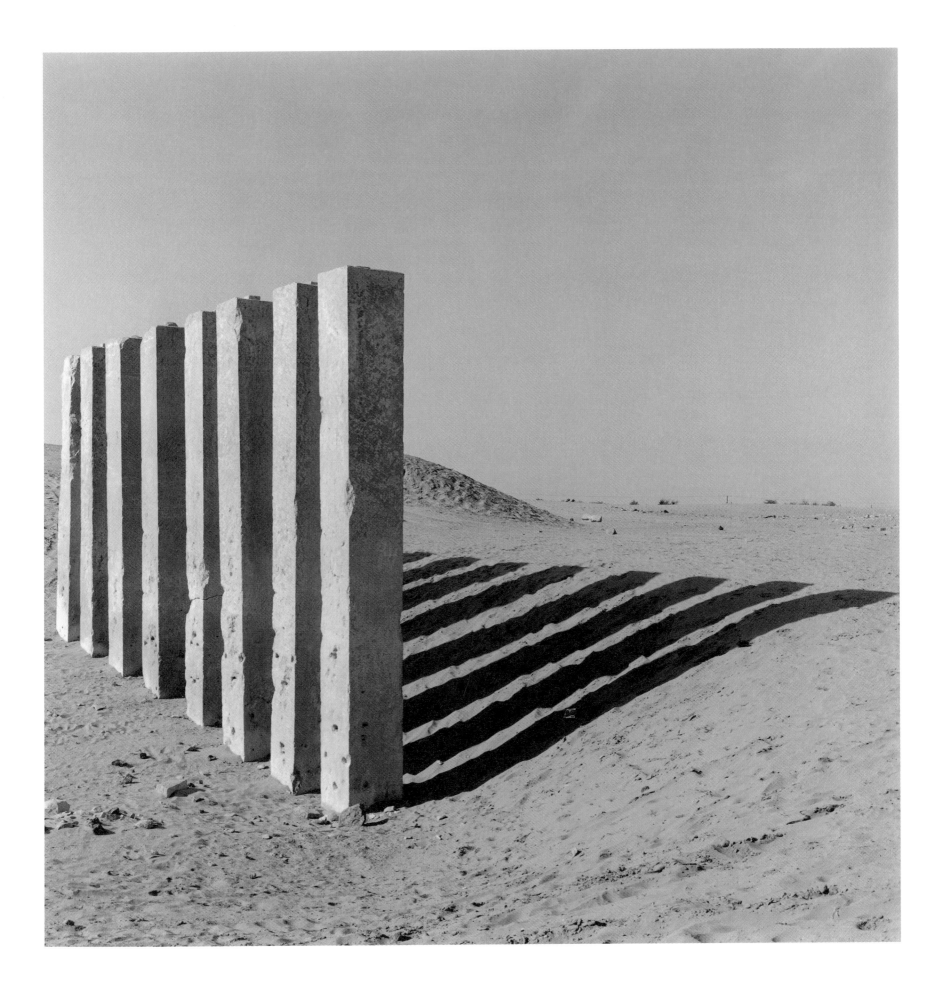

MOSQUE, MALI, 1997

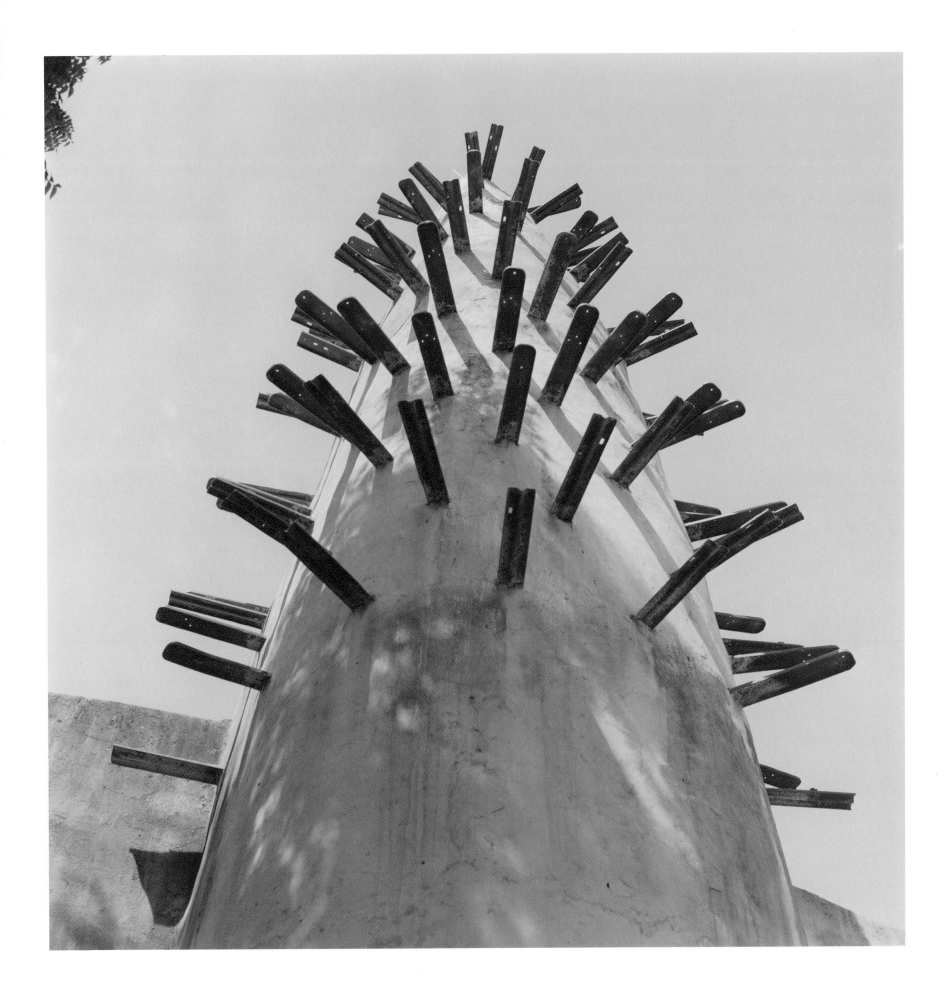

MINARET, PORT OF MOKKA, YEMEN, 1996

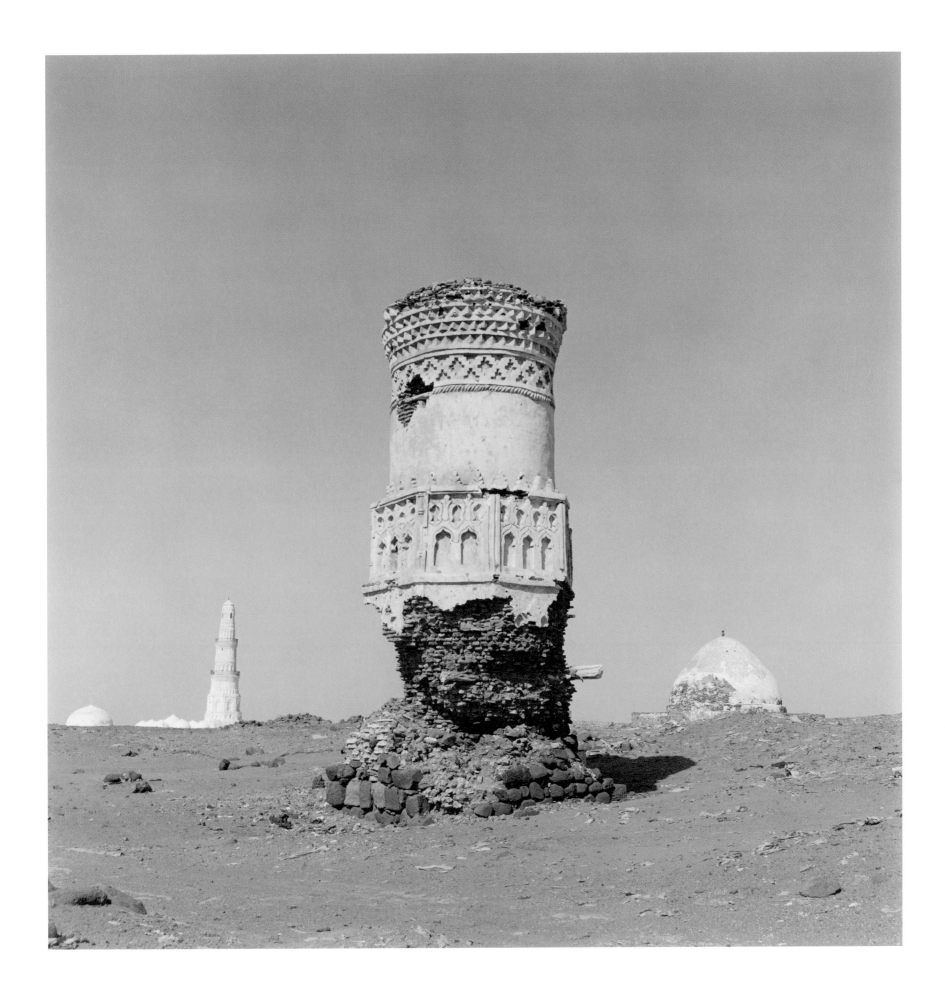

MINARET OF THE MOSQUE OF SULTAN, AL-MAHJAM, YEMEN, 1996

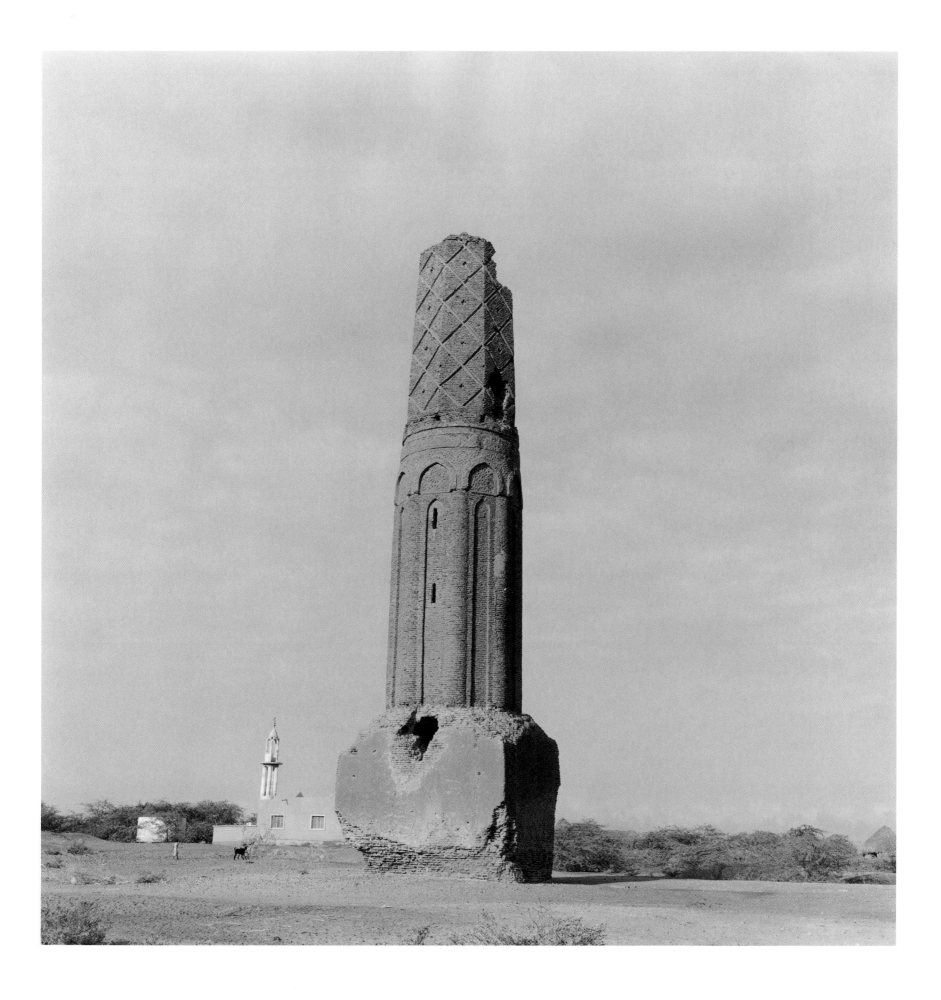

OLD MA'RIB, YEMEN, 1996

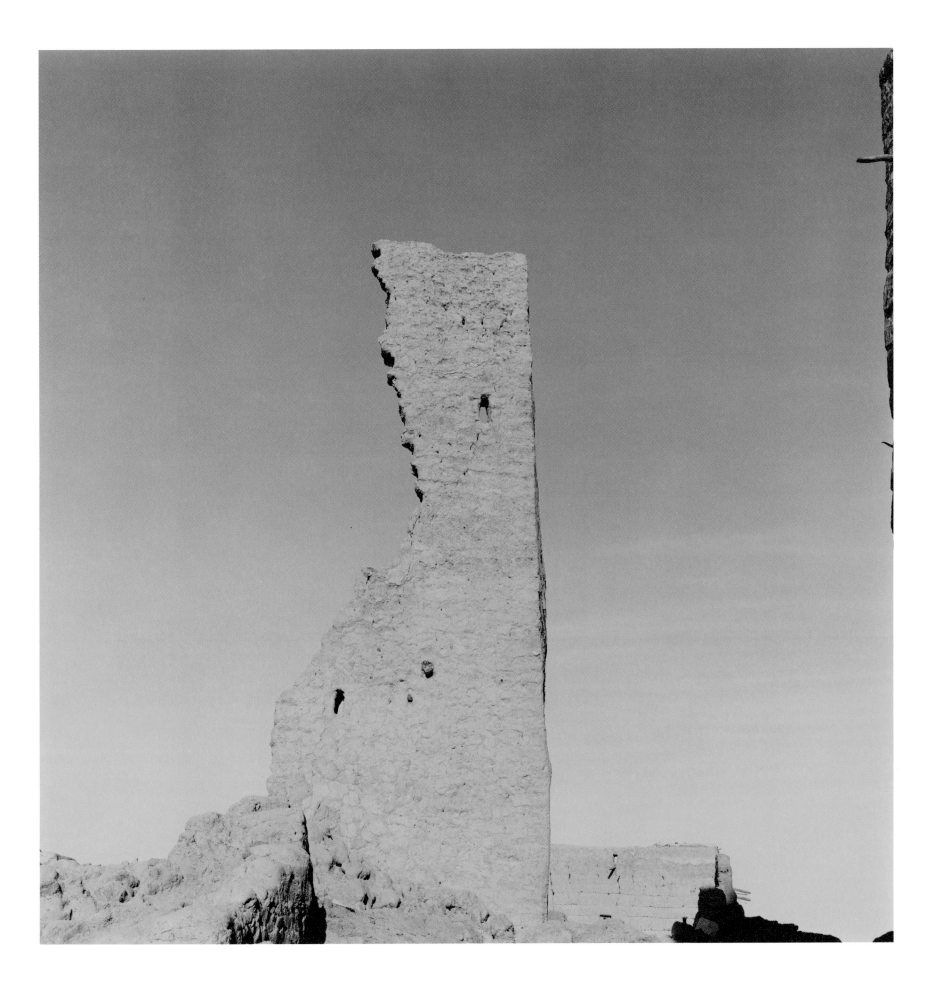

OLD MA'RIB, YEMEN, 1996

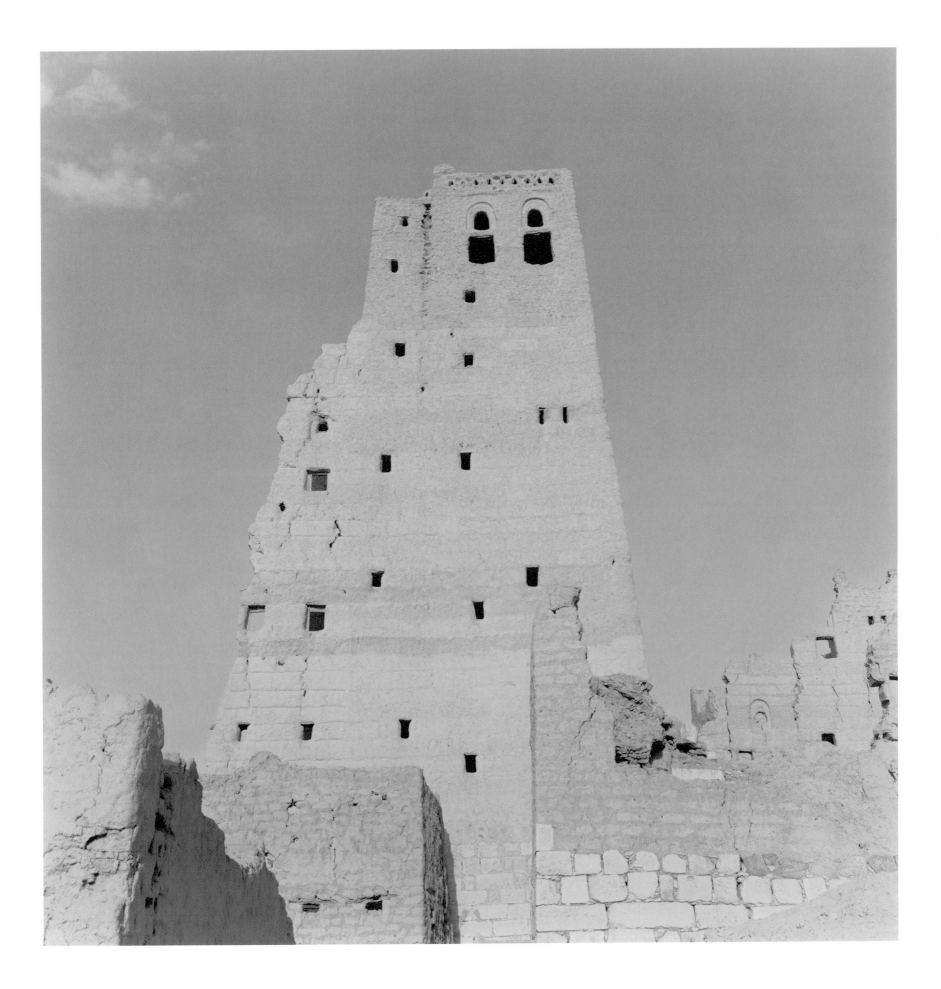

BARRAQISH "YTHL," KINGDOM OF MA'IN, YEMEN, 1996

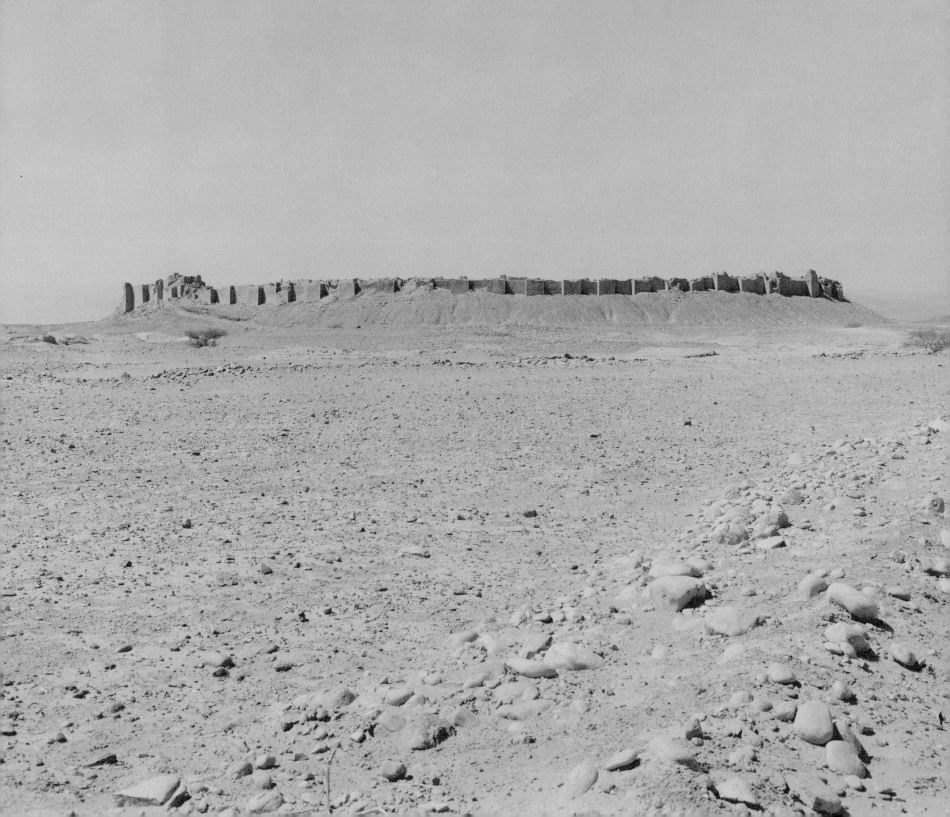

ACKNOWLEDGMENTS

In Memory

Berenice Abbott; Lisette Model; Felicia Sachs; Peter Hujar; Robert Mapplethorpe; James Davis and Ayrev Davis.

Thank You To

Donald McKinney; Frank Del Deo; James Danziger; Barry Friedman; Edwynn Houk; Susan Arthur Whitson; Steven Rifkin; Brad Royce; Joe Hartwell; Mark Sage; Lisa Lyons; Bruce Hartman; Tony Kellor; Dicko; James Wang; Prince Chatri Chalerm Yukol and Kamla Sethi Yukol; Jeri Coppola; Galen Joseph Hunter; and Brian McKee.

To My Family and Friends

Ruth Davis; Maxine Davis; Lee Wurlitzer; Fran Leibowitz; Roberta Neiman; Camilla Smith; Michael Herr; Philip Glass; Mary Ellen Mark; Michael Stout; Lynn Nesbit; Nabil Nahas; Dimitri Levas; David Whitney; Selma Al-Radi; Gita Mehta; Suzanne Fenn; Robert and Johanna Lawler; Bob Rafelson; Toby Rafelson; Paul Siskin; Lyle Berman; Sam Bercholz; Patti Smith; Gelek Rinpoche; and my husband, who has accompanied me to the ends of the earth, Rudy Wurlitzer.

First Edition Published by Arena Editions
573 West San Francisco Street
Santa Fe, New Mexico 87501 USA
505/986-9132 tel 505/986-9138 fax
www.arenaeditions.com

© Copyright Arena Editions, 1999

Concept by James Crump
Art Direction and Design by Elsa Kendall
Edited by David Whitney

Special thanks to Susan Arthur Whitson and Jenni Holder

Distribution by D.A.P/Distributed Art Publishers
155 Sixth Avenue, Second Floor
New York, NY 10013
212/627-1999 tel 212/627-9484 fax

Printed by EBS, Verona - Italy

First Edition, 1999

Trade Edition ISBN 1-892041-07-3
Limited Edition ISBN 1-892041-18-9